Henry Moore to Gilbert & George

Modern British Art from the Tate Gallery

Palais des Beaux-Arts, Brussels
28 September – 17 November 1973

Exhibition organised for Europalia 73 Great Britain by the
Tate Gallery in co-operation with the British Council

**Exhibition presented with the support of the
Commercial Union Assurance Company**

Exhibition design : Stefan Buzas/Alan Irvine Architects, London

Cover
David Hockney *Mr and Mrs Clark and Percy* 1970–1 (detail)
Catalogue No. 106

ISBN 0 900874 67 8
Copyright © 1973 The Tate Gallery

Published by order of the Trustees of the Tate Gallery 1973
Designed and published by the Tate Gallery Publications Department
Millbank, London SW1P 4RG
Printed in Great Britain by Balding + Mansell Ltd, Wisbech, Cambs

Under the Royal Patronage of

Her Majesty Queen Elizabeth II
Their Majesties the King and Queen of the Belgians

Committee of Honour British

The Rt Hon. Sir Alec Douglas-Home	Foreign Secretary
The Rt Hon. Viscount Eccles	Paymaster-General with Responsibility for the Arts
H.E. Sir John Beith	British Ambassador to Belgium
Sir Allan Bullock	Chairman of the Trustees of the Tate Gallery
Sir Norman Reid	Director of the Tate Gallery
N. F. Sandilands	Chairman, Commercial Union Assurance Company
Lord Ballantrae	Chairman of the British Council
Dr F. J. Llewellyn	Director-General, British Council
The Earl of Drogheda	Co-Chairman of the British Appeal Committee
Charles Hyde Villiers	Co-Chairman of the British Appeal Committee

Belgian

M. R. Van Elslande	Minister van Buitenlandse Zaken
M. G. Cudell	Ministre des Affaires Bruxelloises
M. P. Falize	Ministre de la Culture Française
M. J. Chabert	Minister van Nederlandse Cultuur en Vlaamse Aangelegenheden
S.E. R. Rothschild	Ambassadeur de Belgique à Londres
M. L. Cooremans	Bourgmestre de Bruxelles
M. F. De Voghel	Président du Palais des Beaux-Arts et d'Europalia
M. J. Grauls	Ambassadeur belast met de International Culturele Betrekkingen
M. J. Remiche	Administrateur Général de la Culture Française
M. W. Debrock	Administrateur-Generaal van de Nederlandse Cultuur
M. J. P. Poupko	Président de la Commission Culturelle Française de l'Agglomération Bruxellois
M. H. Weckx	Voorzitter van de Nederlandse Commissie voor de Cultuur van de Brusselse Agglomeratie
M. P. Van Halteren	Echevin des Beaux-Arts de la Ville de Bruxelles
M. G. Verecken	Directeur d'Administration des Affaires Culturelles Internationales du Ministère de la Culture Française

Committee of Honour Belgian *continued*

M. A. Van Impe Bestuursdirecteur Internationale Culturele
 Betrekkingen van het Minister van
 Nederlandse Cultuur
M. P. Willems Afgevaardigd-Beheerder van het Paleis voor
 Schone Kunsten
M. M. Mabille Président de la Société des Expositions du Palais
 des Beaux-Arts
M. C. Van Den Bosch Afgevaardigd-Beheerder van de Verenigin voor
 Tentoonstellingen van het Paleis voor Schone
 Kunsten
M. Fr. De Lulle Chef de Service de la Propagande Artistique au
 Ministère de la Culture Française
M. P. Delmotte Adjunct-Adviseur van de Dienst van
 Kunstpropaganda voor het Buitenland van het
 Ministerie van Nederlandse Cultuur

Organizing Committee R. Alley Keeper, Modern Collection, Tate Gallery
 Miss A. Seymour Assistant Keeper, Modern Collection, Tate Gallery
 L. Roussel Representative, British Council, Belgium
 J. D. K. Argles Controller, Arts Division, British Council
 J. Hulton Director, Fine Arts Department, British Council
 Mrs M. Wilson Fine Arts Department, British Council
 Comte Michel d'Ursel Director Europalia 73
 Robert C. De Smet Secretary General to Europalia
 Mme. S. Bertouille Director General of the Société des Expositions du
 Palais des Beaux-Arts—Brussels

 Yves Gevaert Deputy Director of the 'Vereniging voor
 Tentoonstellingen van het Paleis voor Schone
 Kunsten'—Brussels

Contents

Foreword

I welcome the opportunity which has been given to the Tate Gallery to show this group of work by British artists from the National Collection. At first it was intended to begin around 1914 with Wyndham Lewis and the Vorticists, but it rapidly became clear that the space available for the exhibition would have meant a very thin representation over a period of sixty years and so the beginning of the exhibition was brought forward to 1930, which marks another watershed in British painting and sculpture. The artists represented range from a small distinguished group now in their seventies to those who have already made a mark although still in their early thirties.

The Tate buys between 83 and 100 new works every year so that, as the exhibition has developed during the past eighteen months, it has been possible to add some of the most recent acquisitions. The Tate Gallery building is also being enlarged and in two years' time, all being well, we shall have a greatly improved space in which to show the collection. We hope that visitors will be encouraged to come to the Tate when they are in London to see the rest of the collection of which this exhibition necessarily represents only a small part.

Norman Reid

Foreword

The visitor to this exhibition will inevitably find an incomplete representation of the Tate collections. Such an exhibition can do no more than indicate the immense wealth of one of the most important museums in Britain. It will, however, provide an introduction to the work of the foremost English artists of the period 1930–73. The variety of work is particularly striking as is the way in which the styles unfailingly follow those movements which have successively changed the course of painting world-wide.

In this evolutionary process two major figures stand out: Henry Moore is sculpture and Francis Bacon is painting.

Grouped around them are many important artists of such widely different tendencies as expressionism, abstract art, pop art, new figuration. Nor are the most recent movements neglected: conceptual art, land art, etc.

The exhibition was made possible through the highly effective collaboration of Sir Norman Reid, Director of the Tate Gallery, and his assistants.

It could not have taken place without the help and co-operation of His Excellency the British Ambassador, Sir John Beith, without the British Council, especially Mr John Hulton and Mrs Muriel Wilson, without Europalia and without many others whose assistance and support have made its realisation possible. To them the Société des Expositions offers its sincere gratitude.

Suzanne Bertouille

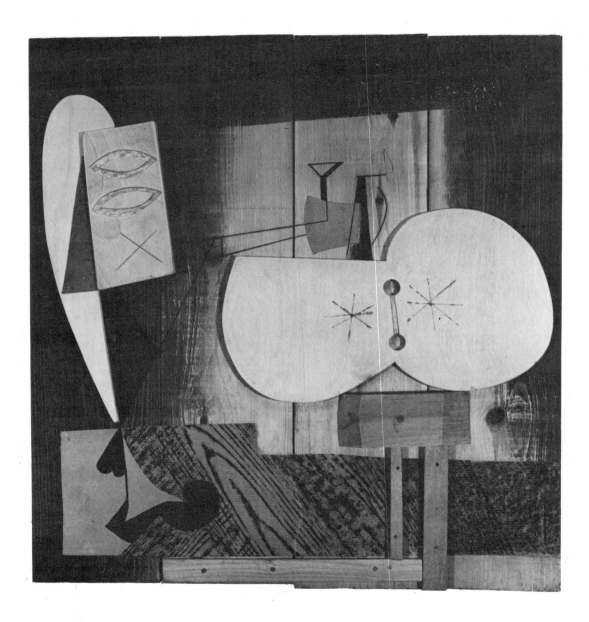

7 **Ceri Richards**
The Sculptor in his Studio 1937 46.5×43×4.5

The Thirties

As well as a time of tremendous activity the thirties were a great moment for grouping and re-grouping. From *Unit One* to *Circle,* from the Surrealists to the Euston Road School artists got together. They exhibited, they produced books, they wrote statements. Brought in touch with the European avant-garde by the younger generation headed by Nash, Nicholson, Moore and Hepworth, assisted by a small group of like-minded intellectuals (notably Adrian Stokes and Herbert Read, who in many ways took over the position Roger Fry had held) British artists gained a new sense of their professional and international responsibilities. Britain became part of a wider wave of activity sweeping the free and the not-so-free world. It was one of those times of social collectiveness and collective awareness which have occurred only rarely in British art; there is a dangerous national tendency whereby the British artist leans towards isolation shunning theories, dealers and foreign influences, to feed off the hump of his own insularity.

Nevertheless the twenties were far from being the area of total directionlessness and regression that has sometimes been suggested, for tentative though some of the work was, this was where a British post-Cubist aesthetic was created, before the thirties put on the pressure. The Vorticist and Bloomsbury artists had let drop the threads of invention in an attempt to find their way beyond pre-war abstraction through a return to the basic principles of naturalist drawing and painting. Though producing fine work they had mostly ceased to contribute new ideas. For some reason they seem to have been oddly unconvinced by their own daring before 1914. The achievements of Wyndham Lewis and David Bomberg, Duncan Grant's and Vanessa Bell's totally abstract paintings (not to mention kinetic abstract paintings) of that period were never built upon by their creators.

The younger generation also looked for basic principles but in a wider range of interests. Their attitudes show that although not obviously influenced by the teaching of Roger Fry and Clive Bell the concept of 'significant form' was ingrained if not explicit in their work: writing in 1932 we find Paul Nash quoting the introduction to Roger Fry's second Post-Impressionist exhibition: 'The artists do not seek to imitate form but to create form.' The notion of abstraction was perhaps the chief preoccupation of the thirties, though it wore many disguises and achieving it was not a simple process. For example Nicholson painted several abstract paintings in 1924–5, but did not develop the approach until the thirties. However the simplification and flattening of his still life paintings, the sophisticated primitivism of his landscape pictures, the emphasis on abstract planar divisions, and on the painting as an object in its own right whose subject matter was its own creation and materials as much as the painted allusion to life it embodied, all added up to a remarkable singleness of purpose.

Ivon Hitchens found a similar need and a simpler solution. He was one of the land-

scape painters preoccupied in the twenties with the evocation of nature through a sensuous fluid use of paint which has something to do with Bonnard, with Braque, with Fauvism and with Cézanne. From this he found a way to produce a pictorial order which did not slavishly reproduce an image of nature: by seeing his subject through a simplified physical application of paint he created a structurally abstract, but referentially naturalistic equivalent to the changes of season and space of his abiding preoccupation. There is a breadth of handling and a formality of structure in his work of the thirties which anticipates much of the landscape-based abstraction in vogue in the fifties.

Moore and Hepworth worked through carving and their response to materials, via Sumerian and Mexican and archaic Greek sculpture, to find a new order and new mythologies not based on the inhibiting details of conventional human anatomy, but on formal relations extracted from a wider view of it. And in addition Moore was already looking closer at the non-human orders of nature—at stones and bones. But it was Paul Nash who to a large extent drew the diverse elements of the younger generation together. He liked to lead and he wielded a certain amount of authority having already established a reputation which in 1932 Nicholson, though a potential leader, did not yet possess. Nash was also entering a new phase of his own work in which abstract and Surrealist structures were juxtaposed and he felt himself, rightly, to be in a front-line position.

Noticing the collective tendency towards abstraction in an exhibition entitled 'Recent Tendencies in British Painting' in London in 1931, he encouraged a number of young artists to join together in the group which became called *Unit One*, exhibited under that name in 1933 and published a book

cum manifesto edited by Herbert Read about the members' aims and beliefs in 1934.

It was clear even at this stage that the interests of Moore, Nash, Hepworth, Nicholson, John Armstrong, John Bigge, Tristram Hillier, Edward Wadsworth and the architects Colin Lucas and Wells Coates were too diverse to form more than a superficial alliance. But Nash was quite realistic about this. The title of the group deliberately combined individuality and unity. Basically it was for 'the modern movement in architecture, painting and sculpture' and against an indifferent public.

Nevertheless it soon became evident after the group's single exhibition that allegiances were becoming much more serious than this loose alliance could permit. By then it was not enough to be united in the vague general feeling expressed by Nash in *Unit I* 'nature we need not deny but art we feel should control'. The division between the Surrealist and the abstract elements inevitably split the group: Nash, Burra and Wadsworth went one way, Nicholson and Hepworth the other, with Moore closer to Surrealism but having a foot in both camps.

The formalist abstract artists were the most closely knit group. Not only did they live near each other in and around Hampstead in North London, they were linked by an international idealism and had some very close international support. In the early thirties Nicholson and Hepworth established relations with, among others, Picasso, Braque, Arp, Mondrian, Gabo, Calder and Hélion and had become members of the international group *Abstraction-Création*. Then as political events in Europe made many parts of the Continent untenable for the avant-garde, as the Bauhaus closed down, refugees began to arrive in London: Gropius in 1934, Moholy-Nagy

and Gabo in 1935, Mondrian in 1938. Artists and architects moved on to America during and after the war in the gradual shifting of the balance of power in art (even before the war it was felt that America was the only place that art could really flourish). But for a brief span London was the centre for front-line art and architecture, although only a few inhabitants noticed the distinguished visitors. For despite their productiveness and energy and the widespread activity of artists in the applied arts there was little market for painting and sculpture.

They had to look for other outlets for their work than *Unit I*. By 1934 led by Nicholson they had taken over the long-established exhibiting society the *7 and 5* and its last show in 1935 was completely abstract. *Axis*, a quarterly review run by Mfanwy Evans and John Piper, appeared between 1935 and 1937 specifically as a review of abstract art, though in the latter stages it was somewhat infiltrated by Surrealism, perhaps owing to Piper's own changing interests. He was moving away from abstract constructions and the Cubist planar abstract paintings, which occupied him around 1935–6, back to looser textures and an expanded interest in the romantic landscape and topographical subjects he had been making earlier. Most of the totally abstract approaches of the decade were formalist, but there was also a short lived interest in the mid-thirties which evolved out of the pure act of painting— out of the brush marks themselves. Practised notably by Rodrigo Moynihan and Geoffrey Tibble it foreshadowed the Abstract Expressionism of the forties and fifties.

By 1934 both Nicholson and Hepworth were working within the range of pure abstract forms, squares, circles and their derivatives, and in a way which had close connections with continental movements such as Purism and de Stijl and with Bauhaus teaching. Nicholson has avoided theorizing about art wherever possible, but Hepworth's writings of the thirties show close relationships to the ideas both of Mondrian and Gabo. In 1935 there was already talk of producing a book devoted to the ideals of abstraction and Constructivism and their modern social and technological context. Edited by Nicholson, Gabo and J. L. Martin it appeared as *Circle* in 1937. Divided into sections covering Painting, Sculpture, Architecture and Art and Life it also included subjects as widespread as town planning, typography, choreography, engineering, art education and biotechnics. As well as Mondrian's essay *Plastic Art and Pure Plastic Art,* there were articles by Gabo, Le Corbusier, Moholy-Nagy, Massine, Gropius, Breuer and others. Meanwhile the international Constructivist banner had been publicly unfurled in Britain at the exhibition *Abstract and Concrete* organized at Oxford in 1936 by Nicolete Gray.

Divided loyalties between Surrealism and abstraction were not only felt in Britain. Neither side could fulfil all needs, both had much to recommend them. What made them especially important was that they produced a wider context for the artist, a place in culture and a place in society.

Herbert Read, who as a writer was able to support both parties, did much towards forming a climate in which modern art could exist in Britain. He seemed to write continuously throughout the decade. Among other publications his immensely influential book *Art Now* came out in 1933; as we have seen he wrote for *Unit One*, he contributed to *Circle* and he wrote the preface to the catalogue of the *International Surrealist Exhibition* in London in 1936, expanding the material into a book

published the same year.

The exhibition had enormous impact, spectators came in thousands to wonder and to jeer. For the public it may have been a sudden event and Salvador Dali lecturing in a diver's helmet a strange sight in the then context of art. Yet many British artists had had leanings in this direction for some time. Nash had been painting in a spirit close to de Chirico since the late twenties, though it was only latterly that he had begun to make *objet trouvé* sculptures and to regard his photographs and *objets trouvés* in the light of art. But Roland Penrose—the chief organizer of the exhibition had been a close friend of Picasso and Eluard since 1926. Cecil Collins had been painting dream-like fantasies something between Blake and Picasso for several years. Edward Burra's interest in the macabre and the erotic fitted uncomfortably into the category of abstraction. Henry Moore had for some time been interested in metamorphosis, multiple readings of an image and the mysterious power of *objets trouvés*. Edward Wadsworth had always shown a preference for objects, and though the Léger-like abstractions of the early thirties give no hint of the marine fantasies in tempera they have affinities with the strange calm of his marine landscapes of the twenties. Ceri Richards, also allied to the abstract group, had nevertheless been making relief assemblages close to Picasso full of ambiguous relationships and incongruous reference.

Read's book showed that Surrealism was not simply a matter of the individualist poet as against the idealistic socially committed Constructivist. Through Read's own essay and the contributions of Breton, Eluard and Hugh Sykes Davies, Surrealism is stressed as part of a continuous line of history, as a need to clarify problems handed down by culture. Furthermore history is discussed not in relation to universal goals, but in terms of individual manifestations. Surrealism appealed to the thinking man unconfined by respectable tradition or forced into grooves against his will. Where the abstract group were seeking unity and clarity, Surrealism looked for multiple meanings and delighted in fragmentation.

If the immediate impact of the exhibition was somewhat smothered by the war the post-war debt to Surrealism in general has been incalculable for artists working with multiple meanings and messages : it is there in the escape from respectability into Pop Art, for example. If in the cinema and photography it has been accepted without question—one even finds it in Coldstream's 1930s film work for the GPO Film Unit—mostly artists have had to fight for the privilege. But from Bacon to Paolozzi, to Hamilton to Kitaj, to Hockney, to Gilbert and George there are plenty of connections, indeed for a long time now the Surrealist aspect has been built into our culture. It is not even something to acknowledge.

It remains to describe a peculiarly British and quite separate alternative to Surrealism and abstraction, and to note the growth of a kind of landscape-based abstraction which has affinities with Surrealism and had also begun to make itself felt in the mid thirties. It was to gain strength during and after the war.

The first began officially in 1937 at 316 Euston Road in London. The School of Drawing and Painting, which was founded there and labelled the Euston Road School the following year, was made up of a group of friends headed by William Coldstream and Claude Rogers and included, among others, Victor Pasmore. All of them have subsequently become very influential teachers. Using a technique which has connections with Degas and Cézanne they

found a major strength in the accurate transcription of the seen world without comment, simply in terms of the craft of painting. A number of the practitioners were, at the time, members of the Communist party and strongly opposed to the bourgeois art of the School of Paris. This is another alternative to the concern with reality which drove the Surrealists and abstractionists. The simplicity of the language and the ordinariness of subject have parallels in literature—in Auden, for example. Coldstream has continued to paint in this way (though others including Pasmore have turned to abstract art) and the probity of his approach has influenced generations of art students.

The revival of the mystery of the English landscape in the later thirties by Sutherland and Piper can be seen as an indigenous alternative to the Surrealist and formal abstract tendencies. The landscape itself and topographical interests make up one side of the coin, the other perhaps covers the feeling that nature and man are produced by the same formative forces. A whole new mythology, a whole new range of subject matter was being invented during that time with Nash and Moore very much up at the front and looking hard at natural structures from hills to stones and bones and shells and bits of wood. As regards subject Sutherland is very much a follower of Nash in the thirties, but in terms of handling of paint, of expressing mood and form through colour and line he is an innovator and influential in his own right. This work is not symbolic as Nash's last phase was, nor essentially topographical like Piper's, though it may depict real places. It contains a new structural approach to landscape which is a synthesis of natural forms and pure painting. And at the same time there is an emotional quality about these paintings which is as convulsive as anything Picasso could do or the Surrealists could wish. It is the same quality which penetrates certain early Abstract Expressionist works. If political events of the late thirties brought back cultural isolation they may also have had something to do with the resurgence of the long-standing North European mood which ranges from angst to despair, from mystery to a vague disquiet, and persisted well into the fifties.

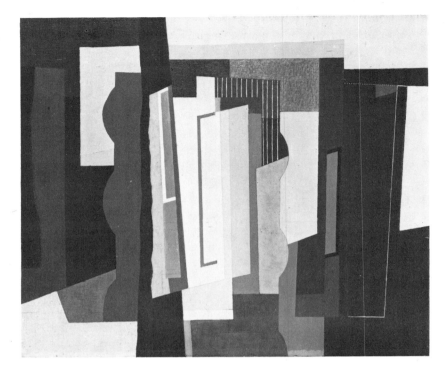

5 **John Piper**
Abstract 1 1935 91.5×106.5

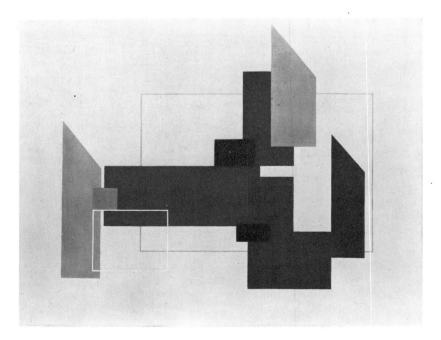

1 **John Cecil Stephenson**
Painting 1937 71×91.5

11 **Rodrigo Moynihan**
Objective Abstraction c. 1935–6 46×36

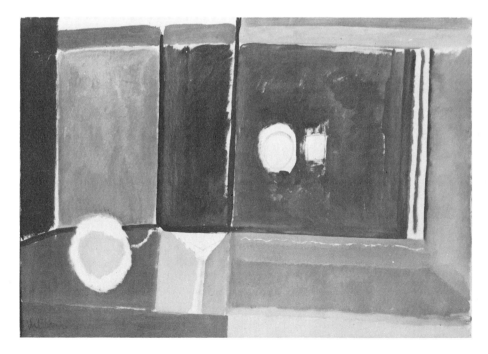

4 **Ivon Hitchens**
Coronation 1937 89.5×122

10 Cecil Collins
Cells of Night 1934 76×63.5

3 **John Armstrong**
Dreaming Head 1938 46.5×78

2 **Edward Wadsworth**
The Beached Margin 1937 35.5×25

8 **Edward Burra**
Wake 1940 each 102×70

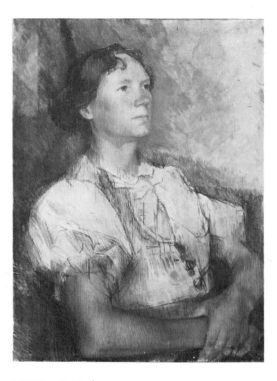

6 **John Piper**
St. Mary Le Port, Bristol 1940 76.5×63.5

9 **William Coldstream**
Mrs Winifred Burger 1936–7 78×54.5

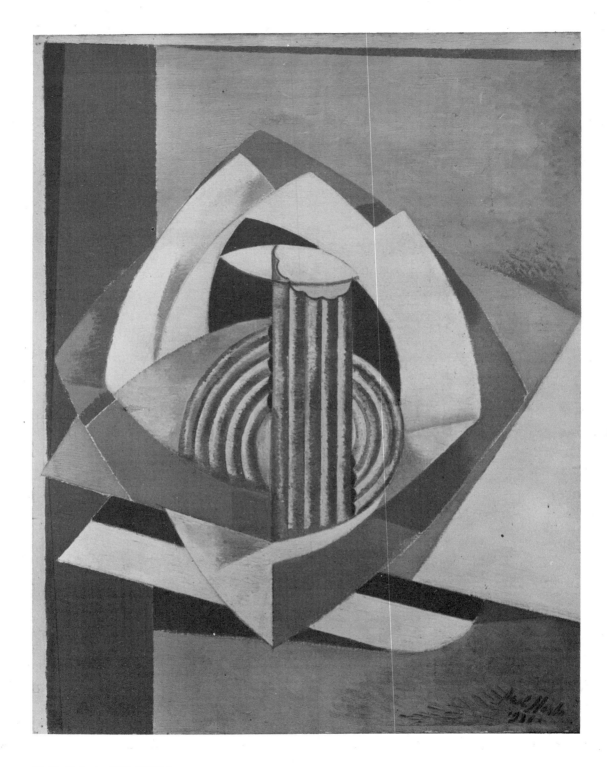

12 *Kinetic Feature* 1931 66×50.5

24

Paul Nash (1889-1946)

With Wadsworth, Paul Nash is the senior artist of this exhibition and at the outset of the period it was he who took the lead. He had passed through a period of great success as an Official War Artist and had overcome the difficulties besetting 'a War Artist without a War'. By the late twenties he had entered a new phase using both the devices of abstraction and of Surrealism.

Essentially a gentleman rather than an artisan his background was distinctly Victorian, even eighteenth century. And it is not too fanciful to see him as a direct link with a much earlier tradition of English landscape painting. His sense of the fusion of time and space, past and present was acute and his work seems to embrace those elements imaginatively in every direction, through the fusion of different time-scales in painting, through the image glimpsed in photography, looking back in his autobiography *Outline* and in the mythology of his work. It draws in the distant past of England, the rising and falling of the tides, the passage of the sun and moon, the symbolism of the equinoxes. Time past, time present and a presage of time future all seem to interpenetrate. His approach has a continuing relevance for young artists today, such as Richard Long and Hamish Fulton, working with the land and with photographs, extending our notions of time and space beyond the object they create.

Nash's early background seems to have been a not irrelevant mixture of private mythology and literariness of a kind strongly inclined towards mysticism, symbolism, poetry and historical romance, typical of late-Victorian and Edwardian taste. His sense of the 'genius loci', the peculiar spirit of certain places, was already important to him in childhood as was the sense of the presence of people in certain places although physically they were absent. A life-long concern with birds, moving perspectives and with the sky also apparently dates from this time.

In his first phase as an art student he fell under the spell of Dante Gabriel Rossetti, attracted partly by his double activity as poet and painter, for Nash too at this stage was torn between literature and art and produced both visionary drawings and poems. In 1910–11 he spent a year at the Slade as a contemporary of Stanley Spencer, Mark Gertler, William Roberts and Ben Nicholson, and his friendship with Nicholson dates from that time when he used to visit the Nicholsons' Whistlerian house in Mecklenburgh Square. The following year Nash was still following in Rossetti's footsteps, living in Chelsea, meeting Sir William Richmond and discovering Blake and Samuel Palmer. He seems to have been artistically quite unaware of the importance of Roger Fry and the activities of the Bloomsbury artists, although he apparently knew of the first Post-Impressionist exhibition Fry organized in 1912, he showed in a subsequent one in Brighton in 1913 and the same year was asked to work for the Omega Workshops.

Nevertheless it was at about this time that the two main directions in his work

PAUL NASH

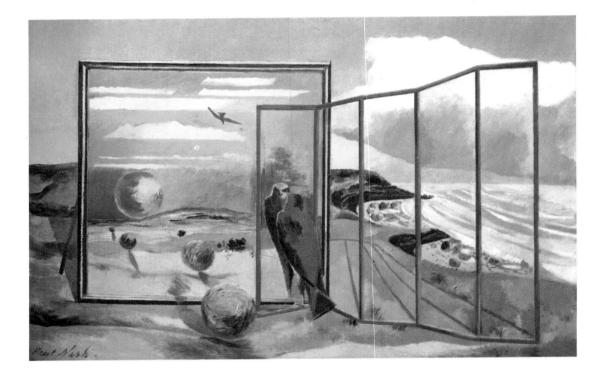

16 *Landscape from a Dream* 1936–8 68×40

began to develop: on the one hand *Pyramids in the Sea* marks the first of his works involving the juxtaposition of things, which are not normally found together (as in the sewing machine and umbrella upon a dissecting table which became one of the stock references of Surrealism). On the other, encouraged by the astute Sir William Richmond, he was also beginning to 'go in for nature'.

In 1912 he wrote: 'I have tried to paint trees as though they were human beings.' He was making his first paintings of single trees and clumps of trees which are invested with a narrative specificness that suggests that there are no others quite like them. It is done through rigorous selectiveness, through specific atmosphere, through the total absence of people, through the relation of the trees to the height of the sky and to the position of the ground a long way beneath. It is a humble kind of approach—as he said 'I can but make drawings as I go from place to place. I know how secret and reserved nature really is and what devotion and homage must be paid her'.

The selectiveness and kind of accurate mystery he had begun to prize at this time stood him in good stead as an Official War Artist in the latter part of the 1914—18 war, but at a much higher pressure. The war paintings forced his abilities into the open. They are simplified, slightly Fauvist, slightly Cubist, brutal and violent. Leafy, curving, peaceful English trees give place to the blackened stumps and barbed wire of Flanders, the cool grass and neatly dotted hayfields to schematic seas of boiling mud.

The ability to simplify and to express himself in paint are the basis for the landscapes of the twenties. But as the powerful and exciting subjects of violence ceased to crowd in on him he had to find an appropriate means of expressing himself without

them. He went back to the search for the elusive meaning of nature at peace he had begun before the war.

There are perhaps three distinct approaches in his work of the twenties. There are the seascapes of Dymchurch; of seawalls and encroaching sea, studies in the relentless juxtaposition of land and water, an all-over structured kind of composition verging on Cubism and Abstraction. Then there is a more lyrical kind of landscape painting close to Cézanne which seems to reflect something of the vogue for the Georgian poets and Nash's appreciation of Edward Thomas in particular. Thirdly there is a style which appeared in the late twenties and has close connections with Surrealism.

Nash was already an admirer of the Italian metaphysical painter Giorgio de Chirico before the latter's one-man show in London in 1928. By the late twenties he was beginning to turn his attention to inanimate objects, emphasizing their characteristics by deliberate simplification to give them the particularly personal quality which before he had given to trees. Their sharp delineation seems to contain something of the moral and metaphysical value which Blake recognized. Mysteriously juxtaposed, viewed from odd angles they set up an interpretation of images which is essentially Surrealist, but also has Cubist connections. A ship at anchor in Toulon has somehow got into a bedroom complete with striped wall paper and a gilt mirror. Many paintings of the twenties and thirties make use of multiple viewpoints and reflections through mirrors or windows, constructing a Cubist play of solid and transparent planes without involvement in the pre-war Cubist style. Sometimes the planes are abstract, but mostly they have a basically realistic form— windows, ladders, studio furniture, scaf-

folding, St. Pancras Station.

Nash recognized the duality of his interests in both Surrealism and abstraction and, although perhaps more than with either he was concerned with individuality, he recognized a common concern for an art that was specifically modern with a basis in abstraction in artists such as Moore, Hepworth and Nicholson which led to the Foundation of the Group *Unit I*. Although an individualist, he was not an isolationist and during the thirties as an art critic he did much to further both the cause of abstract art and of Surrealism, writing about Ernst and Chirico among others. Nor were his activities confined to painting. During the twenties and thirties he taught at the Royal College of Art, photography was important and at times threatened to swamp his reputation as a painter, he did book illustration, stage design and occasional interior decoration.

He had long been aware that 'Art is not primarily concerned with representation. Art is concerned with creation, convention, abstraction and interpenetration, not in order or at the same time but variously and on different occasions.' (Written in 1919). Nature wasn't everything to him, but he never completely did without it. He simplified form into geometrical shapes more to effect the especial clarity of mystery which he valued. Perhaps at first it seemed as if abstraction held the key. We find him writing in 1927: 'To concern oneself with the problem of formal relationships is to escape into a new world. Here one is in touch with pure reality . . .' Yet pure abstract works like *Kinetic Feature* are rare and even here one is led to see the image as a portrait of a particular mysterious object in an abstract or Cubist style.

By 1935 we find him writing in *Axis*: 'I find my piece of world cannot be ex-pressed within the restrictions of the non-figurative world.' He explained 'the hard cold stone, the rasping grass . . . I cannot translate altogether beyond their own image without suffering in spirit—my aim is symbolical representation and abstraction, although governed by a purpose with a formal ideal in view'.

Thus we see him abstracting the standing stones at Avebury into cylinders, but leaving the stubble fields in *Equivalents for the Megaliths*. (A mixture of styles such as figurative artists of the sixties were to make use of.) He makes play with scale and focus and frequent use of *objet trouvé*. He collected, painted and photographed strange objects, frequently using the photographs as sources for pictures, immeasurably widening his field of subject matter, to include for example the texture of rocks or wood, the spatial mystery of shadows, the symbolism of excavations. Magritte called him 'The Master of the Object'.

Nash was a member of the International Surrealist Exhibition Committee in 1936 although he never accepted all the dogma—he wasn't interested in automatic writing and his attitude to dreams and to the act of painting was extremely conscious. For him Surrealism was something essentially necessary and he summed up the situation in England when he said: 'The constipated negativism of our dismal mandarins has set up such a neurosis in the often timid minds of English painters and writers that they dare not freely express their true selves, their real selves, their surreal selves.' In 1933 he defined Surrealism as 'the pursuit of the soul, the attempt to trace the "psyche" in its devious flight, a psychological research on the part of the artist parallel to the experiments of the great analysts.' This is not the attitude of a mystical or visionary painter like Blake. The

symbols he uses have no axe to grind. They are universal, but they also have a sense of the artists' personal mythology pinned down. This is increasingly evident in his last paintings on the theme of the sunflower (the artists' particular emblem from Van Dyck to Van Gogh), and shelters, nests, fortresses, gardens, trees, birds and events in the sky are recurrent preoccupations.

Nash's second term as a War Artist was very different from the first. Owing to the ill-health from which he had suffered since the previous war there was no question of his travelling. The subjects he chose were more symbolic and metaphorical than descriptive. Most were based on the war in the air and in them each kind of aeroplane became a distinct personage. He shows them in the attack and he shows them, as in *Totes Meer*, fallen like giant insects, swept up, dead, broken, piled one upon the other in an unromantic dump at Cowley near Oxford.

The preoccupation with aerial images and with death was also a much more personal one. He was aware that he had not very much longer to live. The feeling is contained in the inexorable timelessness of his paintings of the sun and the moon from the late thirties. He began to be interested (not unlike Paul Klee in similar circumstances) in the myths and rituals of Midsummer Fires, Walpurgis Night, St. John's Eve, The Summer Solstice, The Vernal Equinox. Often in the forties he painted in watercolours to conserve his strength and looking at Chinese paintings his technique became more fluid and the colour more intense.

He left unfinished his four paintings on the theme of the Sunflower and the Sun: *The Eclipse of the Sunflower, The Sunflower Rises,* and *The Sunflower Sets.* In his last essay, *Aerial Flowers*, he made no bones about the role of death in them.

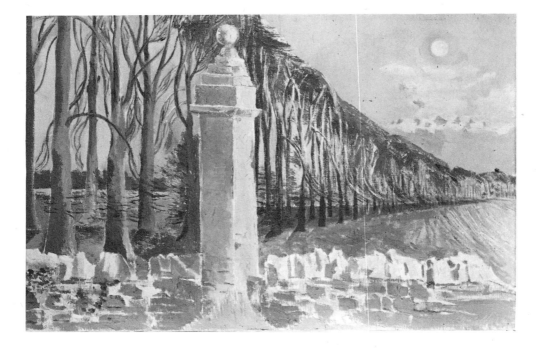

13 *Pillar and the Moon* 1932—42 51×76

14 *Voyages of the Moon* 1934—7 71×54

15 *Equivalents for the Megaliths* 1935 45.5×66

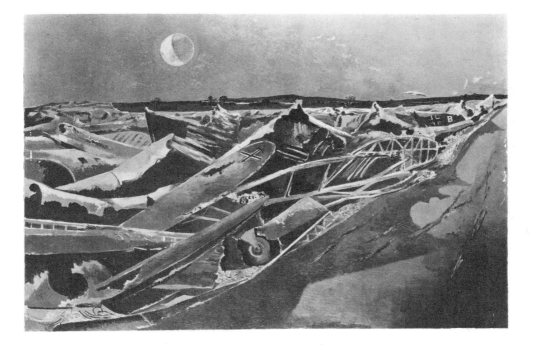

17 *Totes Meer* 1940–1 52.5×101.5

21 *White Relief* 1935 101.5×138.5

Ben Nicholson (1894)

Ben Nicholson did not begin to paint full-time until 1920. That there was painting on both sides of his family may have had something to do with it. From his mother he seems to have acquired something of her dislike of the fuss of 'art-talk'—she used to say it made her want to go and scrub the kitchen table, and she also revealed to him something of the different spatial possibilities in the juxtaposition of colour and tone. Of his father, the noted late-Victorian painter William Nicholson, he wrote 'I owe a lot to my father, especially to his poetic idea and to his still life theme. In my work this theme did not originally come from Cubism, as some people think, but from the very beautiful striped and spotted jugs, mugs and goblets, and the octagonal and hexagonal glass objects he collected. Having those things in the house was an unforgettable early experience for me.'

Nicholson had a perfunctory academic education and spent an unprofitable year at the Slade in 1912—mostly playing billiards, which in the context of his abstract work may be more relevant than the teaching of Henry Tonks. He brushed briefly with Vorticism during the war, but his chief source of education seems to have been in travel. For much of the period 1912–18 he lived abroad, and taken all in all he often appears to be more European than British orientated, making continuous forays to the Continent throughout the twenties and thirties and finally settling in Switzerland in 1958. But if he was aware of the various aspects of modern European art before, he only appears to have become receptive to them from about 1920 when he came under the influence of Matisse, Braque, Picasso and Cézanne and especially of Cubism. He also caught the current interest in primitive art and began to look at the Douanier Rousseau, African sculpture and the artists of the early Italian Renaissance, notably Giotto and Uccello.

While literally hundreds of experimental pictures were destroyed by Nicholson, the ones that survive show the Post-Impressionist, the Cubist and the Primitive as the three main directions of his art in the twenties; he didn't achieve a synthesis of his interests until the beginning of the following decade. Most important of all he was clearly aware of the need to establish an approach which would go beyond Cubism. There are many signposts towards things to come, but these areas remain for the moment unexplored. For example there are views of Dymchurch painted while staying with Paul Nash in 1923 where sea and sky play against each other in a formal structure which looks forward to the planar divisions of the carved reliefs of the fifties and sixties. Then, a little later in 1924–5, there are some entirely abstract paintings where rectangles of pure colour are superimposed and juxtaposed contrasting illusory and physical space through play between pigment, tone and the surface of the canvas, but still tentatively painted and somewhat lacking in force and point.

Then Nicholson moved off on another tack closer to Matisse and the Douanier

Rousseau. With his friend Christopher Wood (who died aged only 29 in 1930) and somewhat under his influence, Nicholson painted a number of primitivistic landscapes and still life paintings during 1928–9. The sophisticated cum naïve simplification of the line and form in these paintings provides a force of expression by its very rawness and simplicity that needs no adding to, no frills. Like his father, Nicholson has always favoured an essential spareness and simplicity of form, but perhaps it is more than anything this *naïveté*, this going back to the beginning, which is the source for the stylish simplicity of his draughtsmanship in the still life and landscape subjects of 1930s onward. At the same time there is a gaiety about the style and subject that is typical of Nicholson's pattern of work throughout his life: while producing magisterial carved reliefs he can also produce a light-hearted and swiftly felicitous drawing of a pair of scissors.

The way in which the bare ground is exposed and paint scraped away to give luminosity to these early primitivizing paintings might also be seen as a pointer towards Nicholson's first reliefs of 1933, where the surface is actually carved and the real fall of light incorporated into the paintings. This notion of the reality of the picture surface's being an essential part of the painting may perhaps originate in his confrontation with a particular area of green in a Picasso painting of 1915, of which he has said: 'In fact none of the actual events in one's life have been more real than that, and it still remains a standard by which I judge any reality in my own work.'

Another related element in his work of the late twenties is the flattening of objects into something symbolic as much as descriptive. One reads them essentially consciously, in terms of reference to actual mugs and plates, as marks placed in a certain way on a surface, more than as illusions of natural form. A row of fireworks becomes a row of flat shapes thin or fat rectangles with a triangle or a pothook on top, and their decorative wrappings stand as decoration and reference in their own right marking a further step. Nicholson had already tentatively used the pattern of a striped jug in an earlier abstract painting. Now in 1929–32 he began to add to this experiment with textures and patterns of objects of all kinds—playing cards, lettering on shop fronts, etc—but in a way which transcends the enforced planar disjunctions of Cubism.

The objects are perfectly recognizable, but they also have connections with pure geometry as circles, arcs and rectangles, while in their composition there is a sense of overlapping planes, which seems to be achieved not so much by superimposition of transparent planes as by a referential and metaphorical cutting back through the surface of the painting. Thus in the early thirties, when he made many visits to France, Nicholson was able to feel on equal terms with continental artists moving beyond the ideas of Cubism. And his development suddenly gathered momentum at this time, partly perhaps due to the general expansion of art at home, but partly also due to being at home in Europe.

The paintings of 1930–2 experiment with illusion in certain ways not dissimilar to Paul Nash's. They involve apparently mysterious planar constructions, reflections, objects, simplification, but with a quite different intention and result. Most important they are paintings first and images second—the image is only read in all its detail by reference to the painting.

In 1941 Nicholson described the kind of thing he was concerned with in a painting

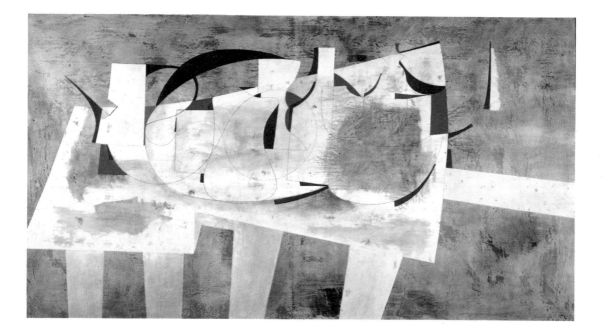

24 *August 56* (*Val d'Orcia*) 1956 122×213.5

called *Au Chat Botté* of 1932. *Auberge de la Sole Dieppoise*, done the same year, is based on a similar idea and the explanation illuminates the one as much as the other. 'What was important was that this name [of a shop called Au Chat Botté] was printed in very lovely red lettering on the glass window—giving one plane—and in this window were reflections of what was behind me as I looked in—giving a second plane—while through the window objects on a table were performing a kind of ballet and forming the "eye" or life point of the painting—giving a third plane. These three planes were interchangeable so that you could not tell which was real and which unreal, what was reflected and what unreflected, and this created, as I see now, some kind of space or an imaginative world in which one could live.' It is surely relevant that both these paintings were made after a visit to Dieppe where Braque was living. Not only here, but in many of Nicholson's still lifes throughout his career, there is a distinct affinity with Braque's work in the spatial construction, in the fluid line and paint and in the use of lettering in the early thirties, a softer more lyrical quality than Nicholson would have found in Picasso.

Nicholson also shows himself interested in other ideas for expanding Cubism. *Plain and Milk Chocolate,* a work of 1933 in which he uses red and blue circles as abstract forms operating in abstract space in a way which suggests knowledge of Miro and Calder, also contains something of Picabia. Influenced by the Cornish primitive Alfred Wallis, as much as by Picasso, he expanded the idea that a painting should be an independent object. *Guitar,* 1933, one of a number of works on irregular surfaces, is unframed and is supposed to hang as a guitar might, straight from a nail on the wall. The surface of the painting is

treated more as if it were carved than painted—it is physically cut into, incised with a pointed tool. In 1941 Nicholson wrote, 'The artificial conditions which have produced painting on a stretched, rectangular canvas without rediscovering this form and later to be framed and sent to an exhibition, have forced painting out of its true direction and out of its natural and direct relationship to our lives, and it is difficult to understand why so many painters accept this convention without question.'

The fluid line scratched in the surface of the paint represents another layer in Nicholson's involvement with the process of making a work of art as a large part of its subject, which links him to Abstract Expressionism as to more recent developments of Process Art. The involvement with materials and the physical activity of transforming them is also a vital part of Moore and Hepworth's attitude to sculpture. But Nicholson's work at this time is particularly remarkable for the rawness and reality of the way in which the materials are presented.

At the end of 1933 Nicholson moved into three dimensions proper with his first relief paintings. Using pure abstract forms of circles and squares he developed from irregular painted reliefs, with the emphasis laid on handling and a certain Dada artiness about them, to the first white reliefs done in March 1934. Charles Harrison writing in the catalogue of the Tate Gallery's 1969 exhibition of Nicholson's work estimated: 'The white reliefs and abstract paintings of the thirties transcend their period and the circumstances of their creation and take their place as the major contribution by an Englishman to the art of the first half of this century. No other English artist has been able adequately to respond to the concept of reality embodied in abstract art.' Suddenly at this stage,

1934, Nicholson's work ceased to have a sense of backward reference; it looked ahead. One should perhaps also add that in that they transcend the boundaries of painting and sculpture the reliefs contributed directly to the lines of thought which made it possible for Victor Pasmore to work in relief, for Richard Smith to work in three dimensions or Anthony Caro in colour.

As in Barbara Hepworth's work from the end of 1934 onwards, these abstract forms and configurations were achieved not rationally but physically, as part of an intuitive manual process. The relationships which make up a work are purely visual, they cannot be understood in terms of geometry only in terms of their own argument. The white surfaces have parallels in Arp and Brancusi, and the uncompromising purity of Mondrian's thought and intention, but one can point to none of them as a real equivalent.

The white reliefs concentrate on the conjunction of light and form. Carving producing its own tonality through depth takes the place of colour. The reliefs absorb and give off light physically—they do not attempt to invent its presence or its shadows. The pieces carved in mahogany produce a more majestic, monumental effect while those made in fibreboard allow for a soft, more diffuse kind of light and a more delicate scale of spatial changes. In the non-relief paintings of 1934–9 colour is used instead of carving to suggest the location of interlocking areas within the pictorial space of the surface. No British artist had previously used colour so directly or abstractly.

Although during the war Nicholson still had the companionship of Naum Gabo, who also moved to Cornwall, and Adrian Stokes was there as well, he had at first little time and space for working. Moreover, away from the international atmosphere the intense concentration of the thirties inevitably relaxed. He had to depend more on the hard core of his own idealism. In this way, almost accidentally, he began a relationship with Cornwall which lasted seventeen years. Always receptive to his surroundings he began to incorporate into his abstract reliefs naturalistic colours which are redolent of Cornwall, and at the same time he returned to painting landscape subjects and still life, sometimes combining the two.

The post-war work continued the three main areas he had already established: landscape, still life and relief, but in new ways and with new connections between them. Nicholson had not altogether abandoned his interest in still life even when working on the white reliefs. And he had already begun to mould the simple objects —mug, plate, bowl, bottle, glass, jug—into a coherent rhythmical whole bound together into an all-over abstract structure of line and plane. The forms of the objects are defined by a simplified essential outline, and their curved or straight edges delimit the planes of the composition in a way similar to cutting circles and rectangles in relief. At first more realistically delineated, they became ever more subtly simplified from the forties onwards as Nicholson used and re-used forms derived over and over again from the range of objects surrounding him in his studio.

Another side of Nicholson's will to achieve a coherent structural form in whatever he does, while retaining a direct response to nature, can be seen in the landscape paintings from the forties and after. The primitivizing simplification of form and fluid, bounding line of the early thirties are further harnessed in the graphic style peculiar to himself in outline views of St. Ives. They mark the beginning of a renewed interest in the planar space of

architecture and landscape, where in a way which connects Cézanne, Analytical Cubism and Nicholson's reliefs of the thirties, the space of, say, the harbour at St. Ives or a town in Italy is exposed, plane by plane, through line which seems to cut back into the surface of the picture. Nicholson has said that the small landscapes required less sustained effort than the abstract reliefs and he has continued to intersperse his grander abstract works with landscape and architectural drawings, which provide him with relaxation and refreshment from their contact with visual reality. As Charles Harrison has pointed out, there have always been two levels of response in Nicholson's work—the immediate and the considered.

Around the end of the war the landscape, combined landscape and still life paintings and the rectilinear coloured reliefs were gradually replaced by the abstract still life subject and a freer more linear kind of abstract painting using quadrilaterals and circles which lasted until 1953. These are important because of the rough-scuffed surface and because of the way they eschew the verticals and horizontals of the rectangle parallel with the front plane to suggest instead a more complex kind of illusion. By giving the quadrilateral an irregular shape the planes begin to twist and turn in space in a way which relates to his late treatment of still life objects and most of all to the reliefs of the late fifties

and sixties, some of which are actually physically curved objects.

Nicholson began to carve reliefs again in about 1953, first on a small scale and in muted colours. And the theme has expanded over twenty years to include projects for free-standing walls, which are intended to be constructed out of doors in the landscape which has given rise to the sensation in the painting, and notably during the sixties a number of monumental abstract reliefs, which perhaps mark the most productive period in his work since the thirties.

Many of these paintings are filled with the artist's experience of particular places— not descriptively, more in the light of essence and reference combined with a sense of the experience of existence. Since the late fifties new kinds of colour have appeared in his work. Silvery whites and greys, umber, pale ochre and dull red have come from his experience of the Greek islands. His preference for stone colour and texture has grown through identification with the texture, colour and structure of the natural world. Cumberland, Cornwall, Brittany, Siena, Pisa and Urbino are all places to which he refers. Nicholson's reliefs are not carved first and coloured afterwards, the artist works the colour into the surface as he goes along, so that his concern is with colour as substance solid or transparent—as it has been since the twenties and thirties.

19 *Painting* 1932 74.5×120

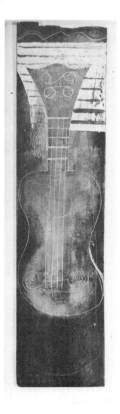

20 *Guitar* 1933 83×10.5 18 *Auberge de la Sole Dieppoise* 1932 93.5×76

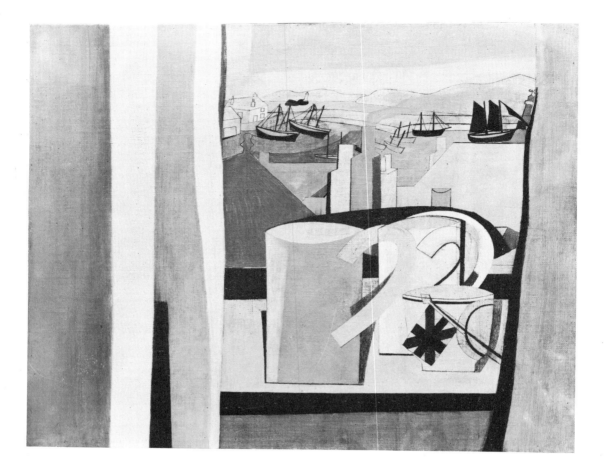

22 *St. Ives, Cornwall* 1943–5 40.5×49.5

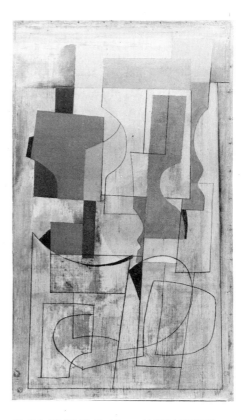

23 *Feb. 28–63 (Vertical Seconds)* 1953 75.5×42

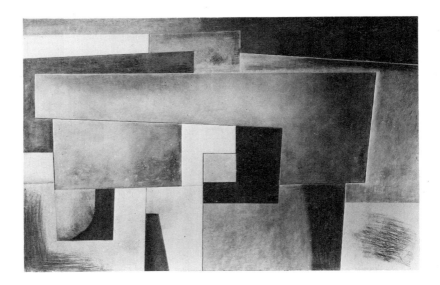

25 *Feb. 1960 (Ice-off-blue)* 1960 122×183

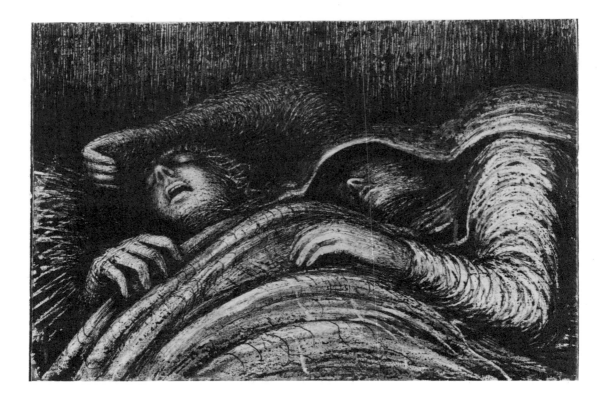

35 *Pink and Green Sleepers* 1941 38×56

Henry Moore (1898)

Henry Moore (like Barbara Hepworth) comes from Yorkshire. He was born in Castleford, a small mining town near Leeds. His father started as a miner and taught himself to be a mining engineer. Moore (like Hepworth) made the decision to become a sculptor early on and acknowledged the encouragement of his schoolteachers, though his father insisted he should also qualify for a secure profession and he was briefly a master at his old elementary school. The Yorkshire countryside and Gothic carvings in local churches were vital formative experiences, but he didn't get his first sight of modern art until after the 1914–18 war (in which he served from 1917 to 1919). This important experience occurred when he went to Leeds School of Art and visited Sir Michael Sadler's collection (Sadler had been Vice Chancellor of Leeds University since 1912), which included work by Cézanne, Gauguin, Daumier, Courbet, Kandinsky and others. At about the same time Moore read Roger Fry's book *Vision and Design*.

From these limited sources and against the background of stifling conventionality of the provincial art school he realized something of the possibilities and something of the magnitude of the task ahead. He also temporarily acquired the 'romantic' view that art schools were useless, though he found he had to revise the impression in order to learn the technical business attached to modelling and drawing without tricks at the Royal College of Art in London.

Here the Principal, Sir William Rothenstein, was as outward-looking in attitude as the teaching in general was not. He encouraged Moore to go to Paris and look at the originals of the Cézannes he had read about in Roger Fry's books and he gave him some introductions including one to Maillol (which he was too shy to take up) and another which got him into the Pellerin Collection. Seeing Cézanne's *Grandes Baigneuses* (now in Philadelphia) there had a tremendous impact and he later described the nude figures 'as if they'd been sliced out of mountain rock'. Many years after Moore was himself able to buy a small painting by Cézanne—also one of his studies of monumental 'Baigneuses'.

Moore recognized the need to work from life and has always continued to do so, but his interests outside the College were much wider. Following Roger Fry's enthusiasm for African art he began his life-long involvement with the British Museum and was particularly drawn to Egyptian, Etruscan Mexican, Sumerian, and African sculpture. In 1922 he encountered Vorticism and began to make his first carvings following the example of Gaudier-Brzeska and Epstein. He was particularly struck by Gaudier's manifesto in *Blast*:

'Sculptural energy is the mountain
Sculptural feeling is the appreciation of
 masses in relation
Sculptural ability is the defining of these
 masses by planes.'

Epstein was a more immediate influence, and after Moore got to know him around the middle of the decade a great personal source of encouragement. He even bought

work by Moore before anyone else showed interest.

Direct carving was something of a fetish at the time. It was not taught in art schools, but the avant-garde students subscribed to the view that modelling and casting was a somewhat disreputable short cut. (There is something similar in the attitude of certain abstract artists in the sixties to the notion of collage.) Almost all Moore's work before 1939 was carved and each piece tended to be an encounter with a new material. Nevertheless, he does not have quite the same attitude towards carving as Hepworth. In 1930 Moore wrote in the Architectural Association Journal that the removal of 'Greek spectacles' from the eyes of the modern sculptor 'has helped him realize the intrinsic emotional significance of shapes instead of seeing mainly a representational value, and freed him to recognize the importance of the material in which he works, to think and create in his material by carving direct . . . to know that sculpture in stone should honestly look like stone, that to make it look like flesh and blood, hair and dimples is coming down to the level of a stage conjuror.'

He liked carving, overcoming the resistance of the material, he still prepares plasters for bronzes with a mixture of modelling and carving, but he stressed in 1961, 'I don't want to put too much stress on the actual act of carving, on the craftsmanship involved.'

Almost all Moore's subsequent themes were given a first airing during the 1920s: the reclining figure, the upright figure, the mother and child, the double head, the thin knife-edge head, the mask, the relief. But in a great variety of styles which are not just references. They range from Mexican and African influence in 1922 to the downright dramatically expressionist peasant primitivism of a mother and child or of

a figure fashionably raising its arms to heaven of 1923, both influenced by Epstein, to the quite classical influence of Maillol in the reclining figures of 1926. The spirit of Brancusi and of various other kinds of archaic and non-European sculpture is often there. Finally in 1929 Cubism led Moore to do his first pierced sculpture formally connecting one side of the image to the other.

Of the important formative non-stylistic influences in the twenties the first was Moore's visit to Italy in 1925, which showed him that his enthusiasm for the intense vitality and wider range of subject in non-European art had to be reconciled with the grand tradition of Masaccio and Michaelangelo. Secondly he began to exhibit his work in public from 1926. He had his first one-man show in 1928 and got his first public commission. This must, one suspects, have given him a sense of responsibility and at the same time of the need to stand on his own feet. He was also beginning to make contact with other artists of his own persuasion. Then, about 1929 he began to collect pebbles, bones and shells. He was starting to think about what the sculptor can learn from non-human natural forms, the balances, rhythms and organic growth of life, and he began to follow his preference for the expressly organic as compared to the geometric, the asymmetrical as opposed to the symmetrical.

In the carvings of mothers and children, half-figures and reclining figures of 1929–32 Moore established for the first time a real combination of his conflicting interests. The reclining figures bring something of the exoticism and energy of carvings of the Mexican God Chacmool to the tradition of European River Gods, the personifications of Night and Day in Michaelangelo's Medici Chapel, and so on. The mother and

child carvings bring something of the cult object or votive offering of Africa or the Cyclades to the narrative, protective humanist tradition of European Renaissance and Gothic religious sculpture. The half-figures of 1930 are similarly affected—they have a note of primitive sexuality combined with a northern spirituality and a twisting rhythm (containing much knowledge and observation) which is aesthetic more than magic. At the same time we recognize that Moore is also considering them as combinations of abstract forms and rhythms: the single vertical form, two forms one within or protected by the other. Parts of the body are given proportions which make anatomical sense only in terms of balance, tension, weight and the play of one against the other.

By 1930–1 Moore was much more in touch with contemporary developments on the Continent. He unquestionably knew what Picasso was doing and from 1931 he did a number of compositions which relate to Picasso's elephantine bathers and his metamorphic abstract inventions of the twenties. It was Picasso who counted most, but looking back Moore described the world of sculpture of the thirties as very small: 'even as a young man from England you could get to know all the people who counted. I knew Lipchitz and Zadkine and Giacometti by 1933 and Arp from about 1933 onwards.'

In 1931 he carved his first more or less abstract sculpture. Two forms interlock with one another, one on top of the other. Although there are connections with Epstein's copulating doves of 1915, with specific Mexican and Cycladic sculpture, with Picasso, the work is explicitly nothing to do with any of them. Like Nicholson in the White Reliefs Moore has leapt ahead and is now moving forward in the front line on his own account. But this is also the point when he began to show his taste for multiple readings which led him towards Surrealism and away from formal abstraction.

Moore invites us to compare a number of possible readings with a form which has meaning only in terms of its existence. It is real as an object because there is no object like it. Moore, unlike Hepworth, has never looked for the ideal or for the beautiful in sculpture. His search has been for strength of a different kind. The overall feeling of his sculpture is closer to a sense of the infinite variety of nature than to a sense of underlying order. Or rather the underlying order he observes is the order of flux and the forces of nature expressed through the infinity of human or animal characteristics. These characteristics may be transposed into natural forms, like rocks or plants or human organisms, but as David Sylvester has remarked Moore, like Picasso, is an essentially anthropocentric artist. Even the, at first sight, most abstract works have a relationship to heads or reclining figures. Two forms together suggests a mother and child, four forms in a row, or a heap the dismembered parts of a reclining figure.

Moore was never a totally convinced Surrealist, he found the argument between the two factions unnecessary: 'All good art has contained both abstract and surrealist elements, just as it has contained both classical and romantic elements—order and surprise, intellect and imagination, conscious and unconscious.' It is typical of his eminently reasonable and stable intellectual attitude. However he was convinced enough to contribute to the International Surrealist exhibitions in London and New York.

The difference between his approach and the Constructivists' shows up well in the last of his abstract biomorphic, metamorphic work of the thirties—the stringed

figures. The inspiration of precise mathematical models in the Science Museum takes on organic shape and connotations, like *The Bride* whose strings form a veil, or the *Bird Basket* whose character suggests a floating ruffled duck and a basket while being, in fact, nothing like either.

Parallel with the biomorphic abstract sculptures Moore was also working on a series of reclining figures which, although they are severely abstracted, do not serve up a simplified notion of the human figure but rather a more complex one. Some are quite small, often in lead, and have an amusingness, a levity about their transformation from nature, in their references to bones and other sources. But some are on an altogether grander scale.

The elmwood *Reclining Figure* at Wakefield completed in 1936 is the first of this series of figures which includes the Tate's hornton stone figure of 1938, elm figures of 1939, 1946 and 1959–64, the UNESCO figure of 1957 and culminates in the closely connected (though not quite in the direct line) two-part figures based on rocks and bones of 1959–62. This is where Moore expands the idea of the pierced form. The figures are cut away, hollowed out, burrowed into with a twisty internal contraposto. Solid and non-solid areas play complementary roles.

These works illustrate as perhaps Moore's smaller more abstract sculpture do not the nature of his contribution to modern art beyond Brancusi. In 1937 Moore was clearly aware of the need to go on when he wrote that it had been Brancusi's privilege to rid sculpture of the 'surface excrescences' which had concealed it since Gothic art and to restore a consciousness of shape. It was necessary to simplify. But, he suggests, perhaps he refined his shape to a degree which was too precious. 'It may now no longer be necessary to close down and restrict sculpture to the single (static) form unit. We can now begin to open out. To relate and combine several forms of various sizes, sections and directions into an organic whole.'

The carved reclining figures bridge the time-gap between the reclining figures of the past, but while assuming a strictly twentieth-century form they also assume a timelessness. Following Gaudier-Brzeska's lead about mountains they take the carving back into the landscape from whence it came, metaphorically, poetically and physically. Physically in terms of invitation and by fixing the speed, the pace, of the spectator's reactions to the object in an environmental way which few have achieved since. Immediately identifiable as an overall image, now human, now landscape, these first opened-out figures also established a close-up relationship between the spectator and the work which was not reached generally until after the war by Abstract Expressionism. In its openness this step in the thirties looked straight ahead to Anthony Caro. In a shorter perspective it has connections with the interests of Nash and Sutherland.

The bare metaphor of the hills was exchanged for the draped figure during the war. Between 1940 and 1943 Moore stopped making sculpture owing to the difficulty of obtaining materials. But during these years he made two important series of drawings as an Official War Artist. The Shelter Drawings, of people sleeping in London's Underground Stations during the air raids, were done in 1940–1 and the series of miners, working at the coal face in his home town of Castleford, in 1942.

Previously Moore seems to have avoided drapery—perhaps because it obscured shape. But in the shelter drawings he found a way to make it enhance the form. It underlines the restless movement of the

uncomfortably sleeping figures, which he particularly remarked, and links them together in a continually moving rhythm. These draperies also have a protective and a vulnerable meaning, they are cocoons, external shelters, a form concealing an inner form. Drapery can reveal form as it strains through it. It can also make a figure mysterious; these are wrapped objects in the Surrealist reading.

It seems to make sense to connect them with his interest in the shell form which may have something inside it. The first *Helmet Head* was begun in 1939 and he went on to make reclining and upright forms on the same basis after the war. But drapery which Moore sees too as mountains, 'the crinkled skin of the earth', also pointed in another direction—towards seated and reclining draped female figures, archaically clothed in armoured gothic draperies and in the clinging skins of Greek dress. Drapery gave the lower part of the body a new vocabulary of shapes of its own.

The wartime drawings were a huge source of images which poured out while Moore was unable to work three-dimensionally: naturalistic and abstract reclining figures which he returned to later; groups of standing figures likewise made use of subsequently; drawings of stones, bones and interior scenes which look forward to later reliefs and seated figure groups. The miners working at the coal face are almost embedded in their environment like fossils and as such look forward to the Bouwcentrum and other reliefs of the fifties (and to similar work by Graham Sutherland). The thin bony backs of these men working look forward to the *King and Queen* while in their taut straining activity they presage the Warriors.

By the end of the war Moore was beginning to be surrounded by public honours and duties, in 1948 he won the

Grand Prix at the Venice Biennale and Wyndham Lewis wrote of him, 'A sculptor is always in danger of becoming something like a public monument—a landmark its significance no longer recognized.' However, there was no sign of Moore's energy flagging or of his becoming an isolated figure. Younger sculptors were visibly to react against his work, but several of those who matured in the sixties including Anthony Caro and Phillip King, worked as his assistants during the fifties.

Following a group of public commissions in the forties treated with a more conventional and classical, though magisterial approach, he began to expand the abstract and metaphorical inventiveness of the wartime and pre-war period in a new way, which also took account of his now frequent use of bronze as a material. The helmet heads acquired in 1950–2 a reference to real armour. Perhaps they contain a note of the beginning of a general revival of interest in Gonzalez and in machine forms, though armour or recently a sun-dial are characteristically as far as Moore will go in this respect. But in the fifties and early sixties Moore frequently worked with natural forms in a way which is more direct, closer to his original sources than before. His interest in natural forms also relates to general current interests, as reflected for instance in the Institute of Contemporary Arts exhibition, *Parallel of Life and Art* in 1953. It has connections with Germaine Richier's metamorphic sculpture, with Ernst and Sutherland. In the fifties and early sixties Moore often used the straightforward tradition of metamorphosis; a child turns into a serpent, a figure can be both Grande Baigneuse and cliff, a shoulder-blade becomes a standing figure communing with the sky. Just as it is vital to notice that the head of Picasso's influential *Baboon and Young*, 1952, is

made up of two toy motor cars, that these are real objects and that the casting of the cars enlivens the surface of the bronze, we find Moore using stone, bone and shell forms in a somewhat like manner in a number of reliefs and free-standing sculptures. They also contain something of the same vital in-built self-commentary, a faint touch of irony.

The theme of a group of standing forms, which started off in the forties as a conversazione with Surrealist overtones of three rather classical draped figures, developed in the fifties into abstract forms more deeply mysterious, something between a totem pole, a Christian monument and an archaic Greek votive offering. Recognition of the layers of reference is surely important. The *Glenkiln Cross* and its related upright motifs are structured out of interlocking bone and stone motifs, but treated on a human level to echo nude figures by Michaelangelo or Rodin. Moore's sculptures before the mid-fifties tend to have a fairly even surface tension, but around 1955 the modulations become much more marked, bone pushing through flesh following the relation of rigid armature to softer plaster, and the figures are much more energetic and twisted in movement. It is interesting that another great humanist, but of a more pessimistic persuasion— Francis Bacon—should have moved in a similar direction.

The idea of sculptures composed of two or more complementary forms, of interlocking forms, or a chain of forms is a basic preoccupation which Moore has developed particularly since the mid-fifties (though it had its beginnings in the thirties). At this time Moore started splitting the reclining figure into two opposing dynamic parts of torso and legs. They are linked by the notional anatomy of the human figure in a way rather like the effect in the Elgin Marbles, where fortuitous abstract forms are produced by the disjunctions and absences of the rest of the composition. Other new variants of the divided figure, which also occurs in three or more parts, are the split head, a round form cloven down the middle and the two-part, flat knife-edge forms—axe-like shapes which seem to have been split by their own potential activity.

The metaphorical, poetic image of the human figure seen from the outside in relation to the rest of things is one part of Moore's work. The interior understanding of it, the empathetic view is the other— how it feels physically to lie upon a bed, to look out from inside one's head, to fall, to sit balanced on a chair, to stand in a group conversing. The complexity of Moore's intuition and understanding in this respect are what links his generation with Cézanne's on the one hand and with the preoccupations of younger artists from Caro to Morris, Burgin and Long on the other.

During the sixties generally Moore's work became more abstract. He began to do stone carving again and forms are generally more spare. *The Three Rings*, though their material is marble, are treated organically yet in their simple unity and repetitiveness they suggest a relationship to contemporary thinking close to Minimal sculpture. Nicholson, for example, has no describable late style, but it is highly tempting to identify one in these sensual, magisterial carvings of Moore's which do in abstract terms what the hollowed-out reclining figures of the thirties do with a landscape metaphor.

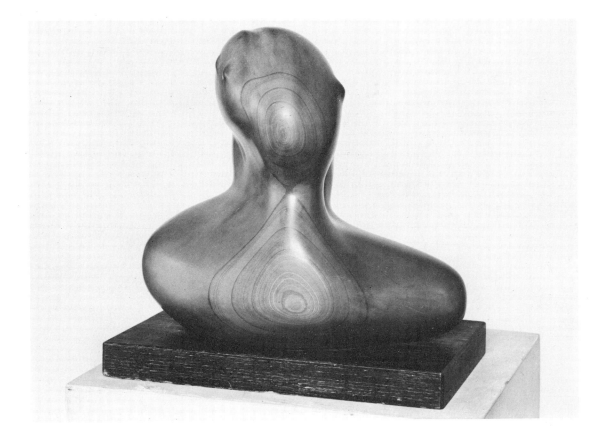

27 *Composition* 1932 44.5×46×30

29 *Four Forms, Drawing for Sculpture* 1938 28×38

31 *Standing Figures* 1940 26×18

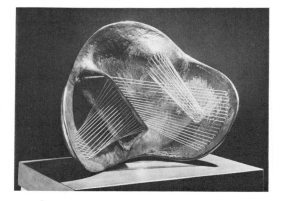

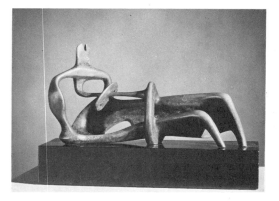

28 *Stringed Figure* 1938–40 27.5×34.5×19.5

30 *Reclining Figure* 1939 10.5×25.5×8.5

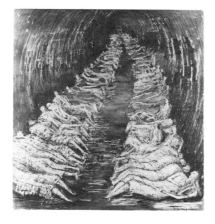

33 *Tube Shelter Perspective* 1941 48×44

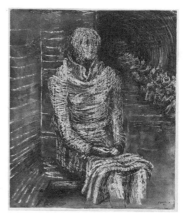

34 *Woman Seated in the Underground* 1941
48×38

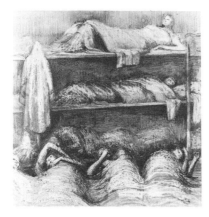

37 *Shelter Scene: Bunks and Sleepers* 1941
48×43

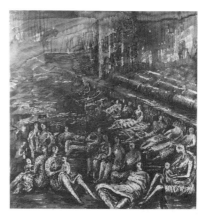

36 *A Tilbury Shelter Scene* 1941 42×38

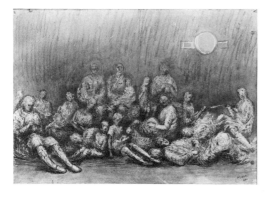

32 *Grey Tube Shelter* 1940 28×38

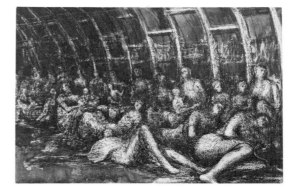

38 *Shelterers in the Tube* 1941 38×56

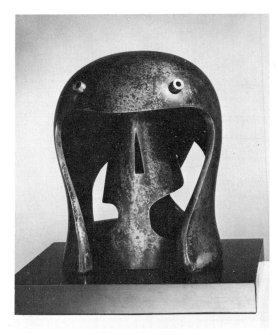

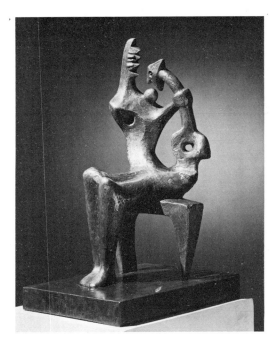

39 *Helmet Head No. 1* 1950 33×26×25.5

41 *Mother and Child* 1953 51×23×23.5

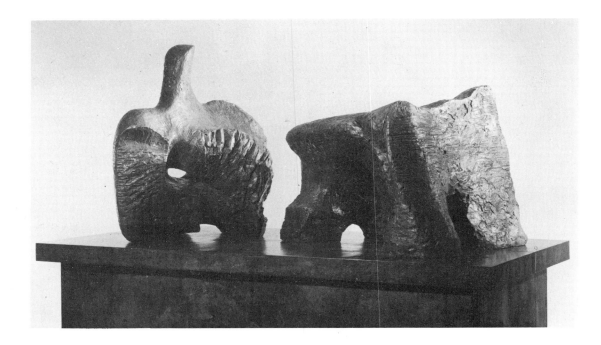

42 *Two Piece Reclining Figure No. 2* 1960 126×258×108.5

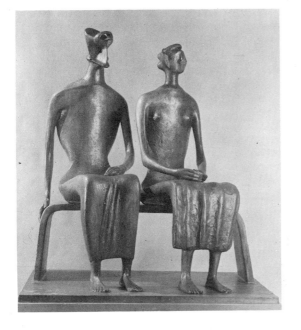

40 *King and Queen* 1952–3 164×138.5×84.5

44 *Upright Form* (*Knife-Edge*) 1966 59.5×57×24

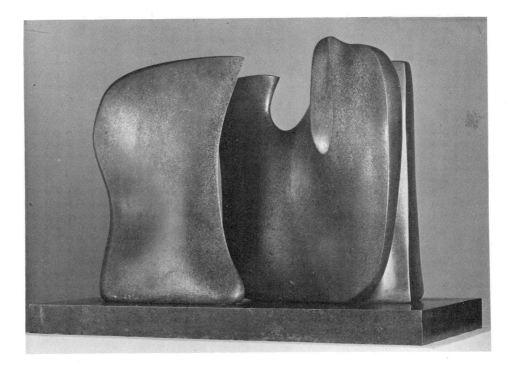

43 *Sculpture: Knife-Edge Two Piece* 1962 50×71×33

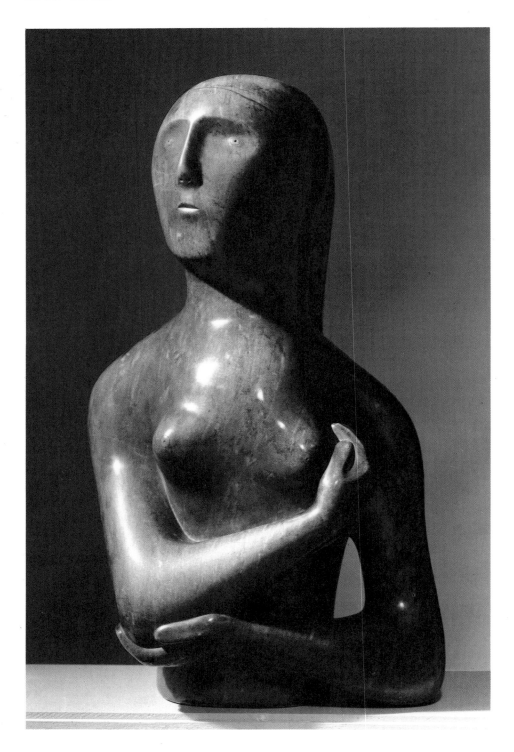

26 *Half-Figure* 1932 68.5×38×28

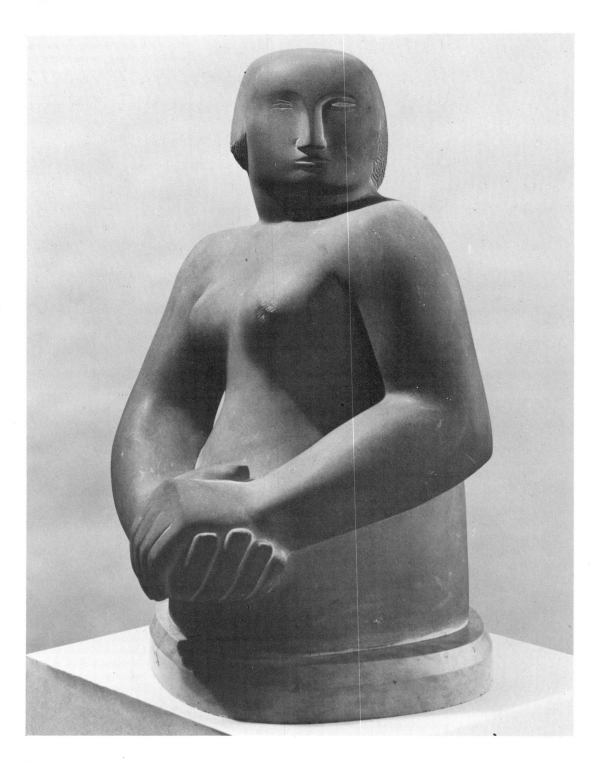

45 *Figure of a Woman* 1929–30 53×30.5×28

Barbara Hepworth (1903)

Barbara Hepworth grew up in Wakefield, a manufacturing and coalmining town in Yorkshire. Her father was an engineer who became County Surveyor of the West Riding. Her determination to be a sculptor was rooted early as were her humanistic idealism and her preferences: it was apparently a lecture on Egyptian sculpture she attended at the age of 7 which started her off.

In many ways her early career ran parallel to Henry Moore's. She met him at Leeds School of Art and in 1920 followed him to the Royal College of Art in London. Here she became aware of the importance of Cubism and of Brancusi. Like Moore, and following the lead of Epstein and Gaudier-Brzeska, she saw direct carving as a way of escaping from nineteenth-century academicism, although working this way meant experimenting at home since carving was not taught at the College.

But unlike Moore, whose inclinations were often towards the exotic and the barbaric, to African and Mexican sculpture, her preference was characteristically more serene and classical, for Egyptian, archaic Greek, Cycladic sculpture. She began to carve in earnest after spending eighteen months in Italy on leaving the Royal College and found much inspiration in the limpid simplifications of early Renaissance (Masaccio and Giotto) and Etruscan art.

Purity has always been important to Hepworth, and in the early carvings she did after learning in Italy how technically to approach and truly understand her material the quality is there in the calmness

and lightness of the pieces and in the economy of the treatment. Light is part of it and one of the most important elements for any sculptor, but it is typical of Hepworth that, even in these early pieces, the block of stone seems to retain the light in a way which is spiritual rather than fleshly. The carvings seem brushed by light and the act of making them is essentially delicate, sharp and spare. There are no deep shadows, none of the robustness of flesh you get in a Henry Moore.

The need to establish a rhythm of work and a personal accord with each material she approached was a conscious preoccupation between 1925 and 1930, and by the end of the period she seems to have felt her response equal to almost any kind of wood growth or texture of stone. Indeed carving has proved itself a positive spiritual need for Hepworth. Since the 1950s her range of media has widened, but her activity is almost always related to carving. Even bronze pieces are carved in plaster using axes, rakes, hatchets, each thing in its different rhythm. While in stone or wood every type of substance offers its own resistance, its own hardness, requires its own delicacy of technique in an activity on which the whole body and mind has to be co-ordinated and focused.

Although in the late twenties and early thirties she was consciously seeking new forms beyond the simple acceptance of the order of human anatomy, it is perhaps more than any other way out of the process of carving that she discovered abstraction. Championing the causes of the

time we find Adrian Stokes writing in the *Spectator* in 1933: 'To cultivate reverence for stone became an aesthetic need. Miss Hepworth is one of those rare living sculptors who deliberately renew stone's essential shape.'

Barbara Hepworth herself declared her interests in *Unit I*: 'It must be stone shape and no other shape. Carving in interrelated masses conveying an emotion, a perfect relationship between the mind and the colour, light and weight which is the stone, made by the hand which feels . . . I do not want to make a stone horse that is trying to and cannot smell the air.' But she goes on to stress 'the predisposition to carve is not enough. There must be a positive living and moving towards an ideal . . . it is not simply the desire to avoid naturalism that leads to abstract work. I feel that the conception itself, the quality of thought that is embodied, must be abstract.'

The contemplation of nature is important, through it she says 'we are perpetually renewed, our sense of mystery and imagination is kept alive, and rightly understood, it gives us the power to project into a plastic medium some universal or abstract vision of beauty.'

The thinking in this manifesto is much akin to Mondrian's, for instance in his concern for 'the great hidden laws of nature which art establishes in its own fashion' *(Plastic Art and Pure Plastic Art)*. But although Hepworth's interest in abstract forms was growing, until 1934 the human image continued to underlie the carvings she did: curving, almost biomorphic forms smoothed the human shape into something natural like a flint or ironstone picked up on the beach—or it could be the other way round. These were shapes which didn't so much imitate as remind one of human shape, and they strongly suggested human relationships—for example of mother and

child, stone within stone or larger stone and smaller stone juxtaposed. Occasionally incised detail (reminiscent of Nicholson's flowing line of the time and of Braque) suggests a hand or a face.

Barbara Hepworth met Ben Nicholson in 1931 and they married two years later. Through him she gained first hand experience of what was going on in the studios of Brancusi, Arp, Mondrian, Gabo and others in Paris. They made several visits to France together and she became a member of the group *Abstraction-Création* in 1933. Brancusi was already a hero, but she now came in contact with the abstract inventiveness of Arp and was much impressed by his all-white pieces. Mondrian's idealism suited her own and no doubt helped to purify it, while Gabo was perhaps their closest link with European art coming to England in 1935 and remaining in close contact right through the war.

Nicholson had already begun his great series of white reliefs in 1933 and when Hepworth returned to carving at the end of 1934 after a short break all traces of naturalism in her work had gone. Instead she was 'absorbed in the relationships in space, in size and texture and weight, as well as in the tensions between forms', which, put rather simply, contains the main principles of Constructivism.

In 1936 the international exhibition *Abstract and Concrete* at Oxford included among other of her works the *Three Forms*. It is at this point that her development moved away from Henry Moore. Whereas he became more involved with Surrealism she threw her energies into the front line of the Constructivist movement. It is surely relevant in relation to her espousal of it that the movement was not purely idealistic, but fiercely and sparely practical. It is clear from her writings that even from childhood she had always cared greatly for man's

relation to his environment and even at a similarly early age had an analytical interest in form which was almost surgical.

Based on the limited range of primary forms she began a fruitful period of work, which by the end of the thirties had established the basis of the themes she was to elaborate after the war: the single upright form, the two pierced upright forms in echelon, the tall monolith of square upon square, the single and juxtaposed spheres and the hollow sphere.

In a long statement she wrote for *Circle* it seems significant that she affirmed her interest in sculpture as a specifically spatial mode of expression. On the one hand she began to consider working on a very large scale, which would involve a greater physical participation from the spectator (although nothing came of it at the time funds being too limited). On the other she began to explore and relate the insides of geometrical structures to the outsides. She became interested in crystal structures (D'Arcy Wentworth Thompson's *Growth and Form* was an influential book at the time) and she also began to infuse her geometrical forms with an inner dynamism by incorporating colour and taut strings.

It was to these stringed figures that she returned after a break between 1939 and 1943 when she did no carving owing to the exigencies of the war, the move to Cornwall and a young family. In these new works the elements had a different meaning: 'The colour in the concavities plunged me into the depth of water, caves or shadows deeper than the concavities themselves. The strings were the tension I felt between myself and the sea, the wind or the hills.'

While keeping her earlier interests in material, proportion and space and the activity of carving, Barbara Hepworth's work gained a new, specific and lasting kind of inspiration from Cornwall, from the ancient countryside with its granite boulders and standing stones and the wild Atlantic coastline. A piece called *Pelagos* done in 1946 contains the idea of St. Ives Bay and its great sweep round to Godrevy Lighthouse. A much later work *Sea Form: Porthmeor* of 1958 contains the essence of the long Porthmeor beach open to the ebb and flow of the Atlantic breakers.

Not that the works with Cornish connections generally start with places and work from there. They start from an idea about a particular shape, but one of the things that seems particularly important about them is the renewal of a human element in the work, which in the thirties had been replaced by the almost magical feeling that resides in the more solid essential forms. Where in the later thirties one could draw a parallel between the existence of the onlooker and the existence of the sculpture one was not specifically invited to do so. Barbara Hepworth has written, 'for me the whole of sculpture is the fusion of these two elements—the balance of sensation and the evocation of man in this universe.' From the forties onwards the spectator is put in a more comparative position.

The frequently open, light, more lyrical work of this post-war period invites the spectator by its very openness to see it as a landscape rather than a microcosm. Its irregular shape and increasing size forces a multiple view and it involves the spectator in comparisons with human scale. The artist anticipated something of this feeling when she wrote of the stringed pieces of the forties: 'From the sculptor's point of view one can either be the spectator of the object or the object itself. For a few years I became the object. I was the figure in the landscape.' Elsewhere she has described

how the forms which have had special meaning for her since childhood 'have been the standing forms (which is the translation of my feeling towards the human being standing in landscape) ; the two forms (which is the tender relationship of one living thing beside another) ; and the closed form, such as the oval, spherical or pierced form (sometimes incorporating colour) which translates for me the association and meaning of gesture in landscape, in the repose of say a mother and child, or the feeling of the embrace of living things either in nature or in the human spirit.'

Although she never returned to naturalism in sculpture there is a renewal of interest in the human figure in her work of the late forties and early fifties. The well-known series of operating theatre drawings done in a style reminiscent of Masaccio or Piero della Francesca dates from this time, as does a series of studies of dancers from life. She also worked on a couple of stage designs, which though abstract in form involved dealing with the movements of people in space. Similarly in sculpture at the beginning of the fifties she worked on multiform compositions in marble inspired by groups of people standing in the Piazza di San Marco in Venice. There is a parallel here with Moore's realistic figure groups from the fifties and also in Giacometti's contemporaneous figure groups, while from a younger generation William Turnbull was to develop the abstract treatment of the theme. Yet Hepworth has not returned to it. She has remained more involved with her earlier commitments—the single standing form and the more intimate smaller group.

Despite the dissolution of her marriage with Ben Nicholson in 1951 the fifties were a period of expansion both for her work and for her standing as an artist. The values she, Nicholson and others of their group had been fighting for before the war had in the meantime become accepted, and their attitudes were even being fought against by a younger generation. They were becoming regarded as the leading modernist figures in Britain and began to be much in demand for exhibitions internationally. Barbara Hepworth represented Britain at the Venice Biennale in 1950 and won the Grand Prix at São Paulo in 1959. She began to receive a large number of public commissions of which perhaps the best known is the memorial to Dag Hammarskjöld outside the UN Building in New York.

In 1954 her first visit to Greece inspired a series of monumental wood carvings and in 1956 she began to experiment with metal for the first time, starting with cut and twisted sheets of copper and brass and subsequently trying bronze. Towards the end of the fifties she returned again to the idea of making very large works which would physically affect the spectator—for example by making him climb through them. It was the continuation of a desire she had felt at the end of the thirties but at the time had to confine to projects for monuments.

Her work has increased in breadth and scope, but the themes have remained constant. Superficially the great steel crucifixion of 1966 seems a new development until one recalls the theme of squares and circles which has been present in her work since the thirties. The pierced form, the two related forms, the curving form all remain but in an infinity of different ways and different materials.

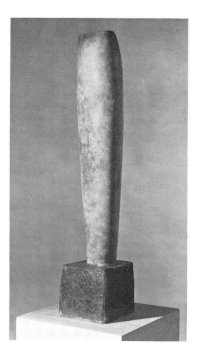

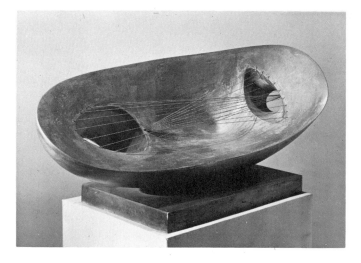

48 *Landscape Sculpture* 1944 32×65×28

47 *Single Form (Eikon)* 1937–8 120.5×28×26

46 *Three Forms* 1935 20×53.5×34

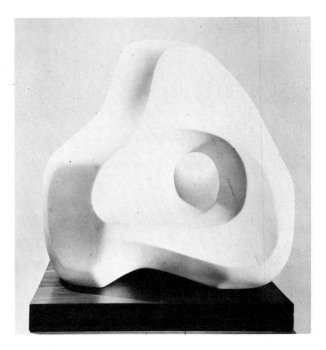

50 *Image II* 1960 75×77.5×48

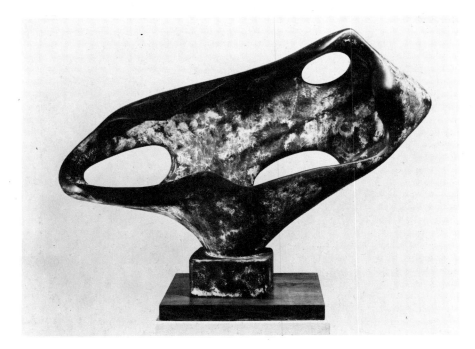

49 *Sea Form (Porthmeor)* 1958 77×113.5×25.5

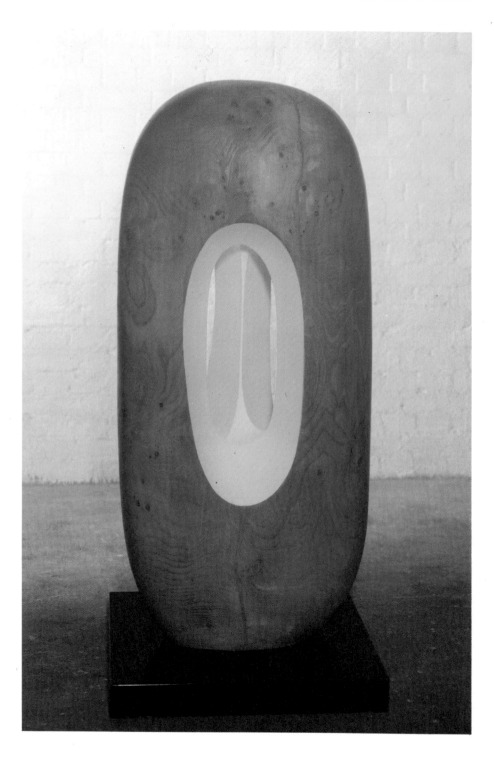

51 *Hollow Form with White* 1965 134.5×58.5×46.5

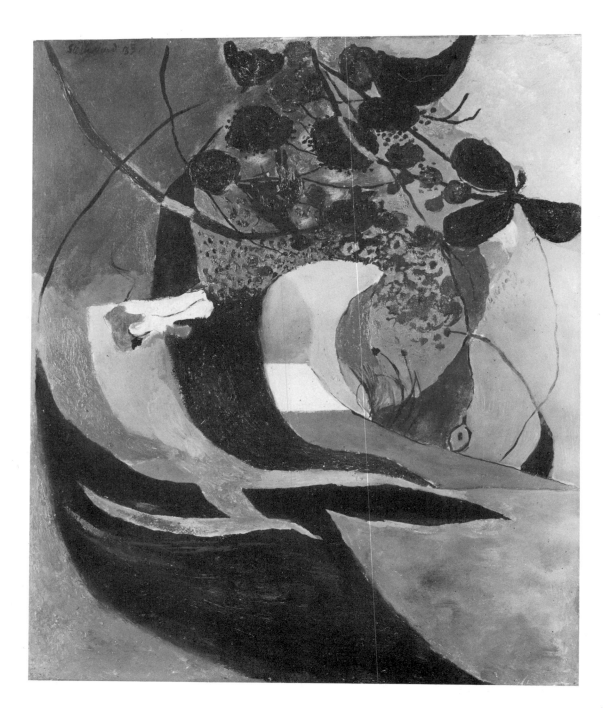

53 *Entrance to a Lane* 1939 61×51

Graham Sutherland (1903)

In his biography of the artist, Douglas Cooper has summed up Sutherland as no one else could: 'Sutherland's pictures transmit characteristically English feelings: an attitude to nature which is ambivalent in its reverence, suggesting at once fascination, awe, and horror; a certain fear of vast open spaces and of the peculiarities of natural formations and growth; a love of luxuriance and of the mystery surrounding the impenetrable; a pantheistic acceptance of the cycle of growth, fruition and decay.'

There is even something of this in Sutherland's portraits. They are as mysterious, potentially dangerous, real and present as the core of a fruit or the gnarled root of a tree, another manifestation of nature which for him is not red in tooth and claw, but beautiful, cruel and rare. This lattitude pervades all his work—landscape, studies of insects and animals, religious paintings, still lifes, fabric designs, tapestries. It has produced a wealth of imagery too rich and too high keyed, too theatrical, for many. But Sutherland's beginnings and his maturity came at a high keyed time; his approach fits with Picasso, Gorky, Pollock and Rothko and even more with Francis Bacon. There is a sturdiness and a structure about his work which denies the potential menace of the objects it depicts. The artist has stood his ground in front of these visions. Whatever private symbolism has conjured them up, Sutherland has a faintly scientific attitude which makes one think of the relationship between Nabokov's passion for fiction and his passion for lepidoptera.

After a brief spell apprenticed as a railway engineer Sutherland studied art at Goldsmith's College from 1921 to 1925. It was here that he began to show his ability as an engraver and to admire the work of the nineteenth-century artist and follower of Blake, Samuel Palmer. Sutherland was seeking an independent romantic view of nature and apparently he felt Palmer to be 'a sort of English Van Gogh'.

Sutherland gained quite a reputation as an engraver, but it was not until about 1930 that he managed to free himself from the pastoral influence of Palmer. After the Wall Street crash of 1929 the bottom fell out of the engraving market and Sutherland began to earn his living by teaching, designing posters, fabrics and ceramics, while he slowly established himself as a painter instead. He destroyed almost all the paintings he did between 1931 and 1934, but in the drawings and watercolours there is tentative evidence of sophisticated leanings which look forward to the loosely brushed landscapes and exploration of mysterious natural objects of the second half of the thirties.

In 1934 the first of many visits to Wales gave him the courage to start transposing his imaginative sketches into paintings, but he was still a very isolated figure in the general context of art. It was not until 1936 at the International Surrealist Exhibition that he came in contact with Arp, Chirico, Dali, Duchamp, Ernst, Klee, Miró and Picasso. He had been asked to contribute by Roland Penrose, but his paintings had little to do with Surrealism proper

—his interest was in the light, space and structure and mood of landscape, albeit rather freely transposed.

These Welsh studies are right in the tradition of British romantic landscape. They have features in common with Blake's watercolour illustrations of Dante and Turner's late paintings. In contemporary art Sutherland admired Henry Moore's treatment of natural and human forms as if they were interchangeable, but Paul Nash was perhaps the artist who meant most to him at the time and who encouraged him to express the things about the natural landscape that for Sutherland had emotional significance.

Unlike Nash he did not primarily create his effect through relationships between objects and between objects and their surroundings. Sutherland's interest has always tended towards the hieratic, often single figure composition—the single root, angel, animal, portrait—and if there are several forms they are complementary rather than disjunctive. Moreover his forms are essentially part of their surroundings. In the work of the mid thirties a unified potency of style and mood is already established, and in the watercolours in particular (the paintings tend to be more formal) there are looser abstract rhythms and a revolutionary fluidity of handling which has connections with Kandinsky. The forms of the rocks and hills are described by the calligraphy of the act of painting them. Sutherland does not here analyse objects so much as create them through painting, out of an emotional idea based on landscape and natural forms.

In *The Painter's Object*, published in 1937, Sutherland described a Yorkshire landscape in terms which perfectly evoke his paintings, as a small extract is enough to show: 'It is a primitive environment. A wide plain surrounds us. It is redeemed from emptiness by the road which curves across it. The attention becomes drawn to an irregularity of contour on the horizon. Lit by the effulgent figure of the sun, which hangs low behind, innumerable sharp forms cut brightly into the sky. Their outlines, devoid of order or rhythm, confuse the eye as the crazy cacophony of village church bells confuses the ear.' He goes on to tell how 'the rocks lie in every direction', and how 'the setting sun turns the stone in its bed of bright green moss and blackened heather yellow, pink and vermilion.' The dramatic gloom and the scientifically observed sunset are part of the nineteenth century, but the simplifications and the synthesis of objects and mood and landscape go beyond Neo-Romanticism.

In 1938 Sutherland's work took on a new and galvanic quality and he began to concentrate on strange, isolated, natural objects which rear up from the ground in a way comparable to the spiky, writhing forms and upward thrusting heads in Picasso's *Guernica*. The painting and the studies for it were shown in London in 1938 and Sutherland seems to have been much impressed: 'The forms I saw in this series pointed to a passionate involvement in the *character* of the subject whereby the feeling for it was trapped and made concrete.' Sutherland's *Blasted Oak* of 1941 seems to convey something of the same feeling of nature in agony, though without the overt political comment. The paintings of the late thirties take further Sutherland's fascination with hidden places and the ambiguity of natural forms. The war built up his preoccupation with objects into something which in its metamorphic suggestiveness relates to Picasso's *Dream and Lie of Franco* at one end of the scale and to Oldenburg at the other.

Sutherland was employed as an Official War Artist throughout the war and painted

a wide range of topics from suburban houses to tin mines and wrecked railway trains. The styles are more varied than before while retaining a romantic bias. The mines and quarries, the rock formations and slag heaps suggest the schematic rocks of the Renaissance and the sheer stone faces of Blake, the burnt out paper rolls owe something to Leonardo and the bombed buildings to Piranesi. The iron foundaries have the atmosphere of catacombs. Always there is the sense of energy throbbing away and of the contrast between the natural power of landscape and the smaller activities and disasters of man.

The more visibly humanistic theme which characterizes these paintings continued after the war. One of Sutherland's recurrent preoccupations since 1945 has concerned specifically Christian subjects. Sutherland is a convert to the Roman Catholic Church and his attitude has more in common with perhaps Eliot or Fry than with Moore, but there are parallels with Moore's wartime and post-war preoccupation with figure subjects and both artists were employed on commissions for St. Matthew's Church Northampton—Sutherland to do a Crucifixion and Moore a Madonna and Child. After the war there seems to have been a general wave of humanism, compassion, a reaffirmation of faith, and with it in art a certain feeling that artists should re-establish themselves in relation to the great subjects of the past. In France there is Matisse's work at Vence. Though perhaps it was only in America that the feeling found expression in the front line of the modern movement—in Barnett Newman.

For Sutherland the subject of the Crucifixion embodies a specific feeling of hope—within death mankind, and perhaps nature in the wider sense, finds its salvation. He was aware of Grünewald's Isenheim altarpiece and of Picasso's 1932 studies after it, but the catalyst which showed him how to treat the subject was a booklet published by the United States Information Services containing photographs from Auschwitz, Belsen and Buchenwald. This hardly involves a specific use of photographs as Francis Bacon has made, but it perhaps serves as a reminder that Bacon and Sutherland were close friends at this time and moreover that Bacon's own *Studies for Figures at the Base of a Crucifixion* were exhibited in 1945. Bacon was probably influential for Sutherland at this time, though it is interesting that the actual way they handle paint is closer around 1950–55 when both occasionally painted animal subjects.

During the time of the gestation of the Northampton Crucifixion Sutherland also began to paint related pictures of thorn forms which went on into 1951. There were thorn trees, which suggest a two-legged body surmounted by thorns, and thorn heads where the spiky agony is circular in movement and evokes a great cry of agony, the open mouth of a baby bird, and a communion monstrance containing the symbolic blood of Christ. A further addition to the tradition of Edvard Munch's *Cry*, of Picasso's open spiky-tongued mouths and Bacon's silently screaming heads. Sutherland has also painted a Deposition and a Christ Carrying the Cross, a further Crucifixion and a Noli me Tangere, though the best known of his religious subjects is the huge tapestry *Christ in Glory* for Coventry Cathedral showing Christ in a mandala surrounded by the symbols of the four Evangelists and with a Crucifixion beneath. It formed a large part of his activities between 1952 and 1957.

Following and concurrent with the thorn paintings Sutherland began a series of decorative, hieratic plant and insect

subjects—palms, pergolas, gouards, maize cobs, grasshopper and mantis images—which concentrate on the front plane and the picture surface. Picasso's paintings of the thirties and forties produce an all-over surface pattern which parallels the preoccupations of abstract painting in much the same way, and Sutherland was apparently looking at Picasso a good deal just then. But Sutherland's preoccupation is abidingly with nature and the outcome is very different. The subject matter in these paintings relates to the fact that he began to spend much of his time in the South of France from 1947 onward and his paintings take on the dryness, high colour and exotic quality of the Mediterranean landscape, flora and fauna, in contrast to the cool lushness of England.

At the same time Sutherland also became interested in geological and fossil forms, in petrified frozen nature so ancient in feeling, so oddly armoured and structured for its existence to be beyond our comprehension. The strange forms which Sutherland depicts have parallels in the paintings of Max Ernst and the sculpture of Henry Moore and Germaine Richier. They also perhaps relate to a younger generation of English sculptors: Paolozzi, Chadwick and others, though Paolozzi's forms are more emphatically mechanical. When Sutherland paints a machine as he frequently does in the fifties, a hydrant for example, it seems to testify to the source of mechanics in natural form. It suggests the spirit of a hydrant or an earlier age. Such forms seem to be substitutes for human figures. There is something fetish-like about them and a continual sense of human connections.

In the late forties and fifties Sutherland also made paintings of both animals and humans which are little or not at all transformed by the process of allegory and abstraction. The monkeys, toads, birds, bats and snakes are nearer his abstract style. The portraits are straightforwardly realistic. Sutherland's approach is always based on a will to find the key to the construction of his painting in the structure of natural form. The endless process of reduction and synthesis in the landscape subjects may well be one of the things which has made him a remarkable portrait painter. But it is not quite true to say that he paints a portrait as if it were a log or an eagle. The portraits are on a grander scale and in many ways conform to convention. The figures fill most of the canvas, the human being is not shown in a natural context, he creates his own. There is less pure painting here than in Sutherland's other pictures yet there is a similar underlying firm network of horizontal and vertical rhythms which gives a hieratic sense and an abstract structure. Sutherland could have painted them in his other style—why didn't he? Perhaps it is something to do with his essentially naturalistic approach, as he knew he could recognize the features of a personality he could not deny them. Perhaps it is to do with the challenge of an approach with a great tradition behind it. Perhaps it had something to do with a sense of duty. Whatever it was, these are some of the best portraits of the twentieth century.

During the sixties Sutherland continued to work along the lines he had established, but more recently he has brought the natural forms back into a dramatic landscape setting. He has been felt both to be an influential artist and to be an influence demanding reaction. The younger generation of abstract painters who matured in the sixties felt the dangerous power of landscape-based abstraction in the fifties to be personified in his work and sought a purer abstract approach. Sutherland is both an independent artist and a transitional

figure. His work is full of links, back into the nineteenth century, forward with Moore and Bacon to find a style beyond Nash and Picasso, which bridges the gap between the organic and the mechanical aspects of life. His work fulfils an imaginative need with which no other artist concerns himself today.

52 *Welsh Landscape with Roads* 1936 61×91.5

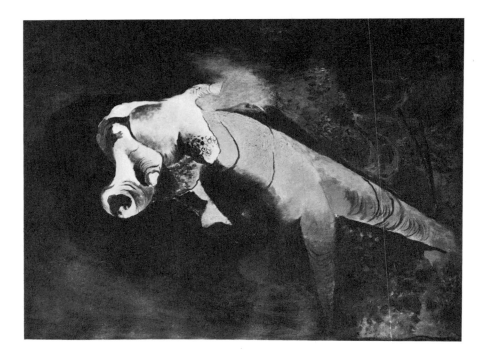

54 *Green Tree Form* 1940 79×108

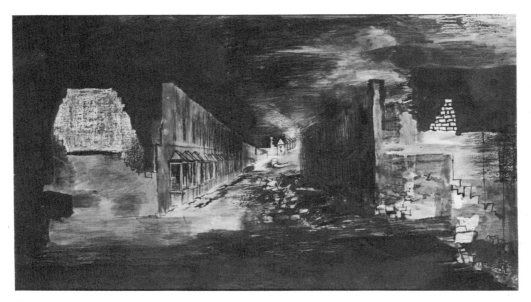

55 *Devastation, 1941: An East End Street* 1941 64.5×113.5

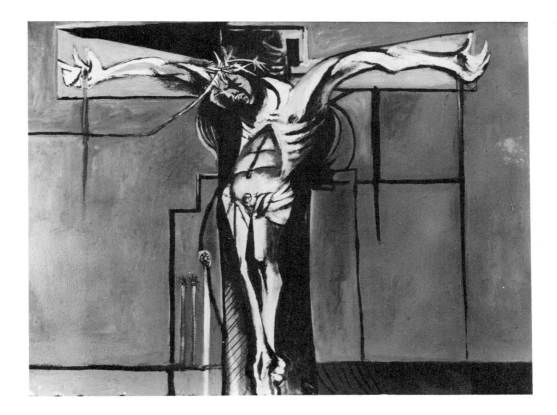

57 *Crucifixion* 1946 91×101.5

58 *Somerset Maugham* 1949 137×63.5

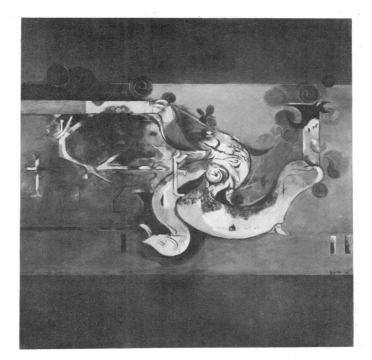

61 *Form over the River* 1971–2 221×309

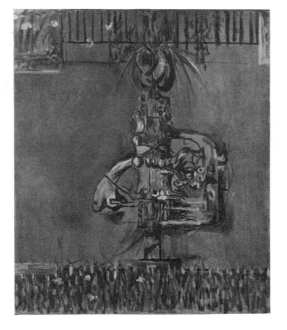

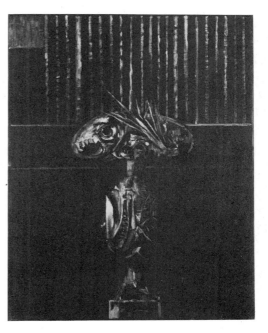

60 *Hydrant II* 1954 112×90.5

59 *Head III* 1953 114.5×88.5

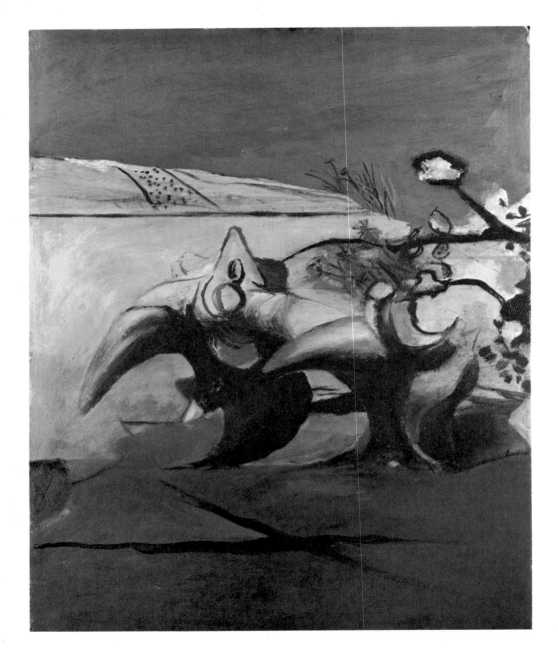

56 *Horned Forms* 1944 81×64

66 *Linear Motif in Black and White* 1960–1 122×122

Victor Pasmore (1908) and Constructivism

Victor Pasmore did not begin to paint full-time until 1937 when he was nearly thirty. However, he was not unaware of the avant-garde activities of the period. He passed through a number of stylistic phases and adherences before establishing himself as a revolutionary painter in the late 1940s, but in retrospect his interests all seem to point in that direction and to suggest a coherent personality.

While still at school he showed a remarkable interest in the theoretical side of art which was to reveal itself as a characteristic trait. At this stage he was reading Chevreul and making notes on the colour of Turner's paintings in the Tate Gallery. At the same time he also showed a natural gift for pure lyrical painting in the Impressionist and English landscape tradition.

During the late twenties and early thirties he came in contact with Post-Impressionist and Cubist painting, especially Braque, Picasso, Matisse and Bonnard. And although his work was more Fauve than abstract he took part in the 1934 Exhibition *Objective Abstraction* where Moynihan, Tibble and others showed work based on the activity of pure painting. In the catalogue Pasmore stated, 'I do not paint directly from nature, I endeavour to paint in relation to natural forms. I have only an uncertain idea before I begin. I proceed as the painting demands until I have realized it in as complete and satisfying a form as I can.' Subsequently he did do a few abstract paintings influenced by.the exhibition and by Ben Nicholson,

but destroyed them because they did not fully 'engage the mind'.

By 1936 Pasmore was working from nature in a more objective way, following Sickert, Degas, Cézanne and Bonnard, and in 1937 he joined with Coldstream and Claude Rogers in opening the Euston Road School. The anti-romantic, more disciplined atmosphere probably developed his awareness of the function of form and colour, but the handling of his work still remained traditional.

Then between 1943 and 1947 it gathered momentum. He began a purposeful exploration of the theoretical writings of French painters from Cézanne to Seurat and realized that the road towards abstraction they indicated was the direction he had to follow. The Picasso exhibition in London in 1945 apparently confirmed his view—he didn't much like the paintings, but he saw the point.

Yet the riverscapes of Hammersmith and Chiswick of 1943–7 still show him unwilling to make the leap—perhaps he was afraid of loosing the thread of intellectual understanding as he had done earlier. He first developed a simplified, but complex planar approach close to Cézanne and Euston Road principles, with perhaps a network of bare tree branches linking the planes and the surface as in Nicholson's Cornish landscapes, but a grey misty Whistlerian atmosphere. Then around 1946–7 he began to emphasize the surface and to blur the naturalistic landscape images even more by combining the brief surface grid of lines with abstract areas of

dotted pointillist foliage.

Finding these works seemed to fall between two stools—they were neither abstract nor figurative—Pasmore began once again to concern himself with theory, this time turning to Kandinsky, Mondrian, Arp, Klee and others. The first abstract painting he did since the thirties was, in fact, based on a particular work by Klee which he saw at the exhibition *Forty Years of Modern Art* in London in 1947. Soon after this he also began to make collages (affirming the notion of the painting as object rather than imitation or representation). And his first entirely abstract exhibition was held in 1949.

The abstract artists from the pre-war generation were apparently delighted at the turn of events, but their reaction highlights the scattered situation of modernism at the time. Nicholson invited Pasmore to join the Penwith Society and Pasmore made a number of visits to Cornwall on which he discussed abstract art and received much encouragement from Hepworth and Nicholson.

It was Herbert Read who pinpointed Pasmore's conversion to abstract art and subsequently to Constructivism as 'the most revolutionary event in post-war British art'. While the assertion is questionable out of context, it was certainly one of the things which helped to set British art back on its feet.

Pasmore's development was completely independent of American and European post-war abstract developments (it soon had to compete with them) and it was influential in a number of ways. He carried further the ideas of the Constructivist movement of the thirties; for example the integration of art and architecture and as an environmental phenomenon. His most notable contributions, among a number of murals and reliefs in public buildings, were

as practising consultant architectural designer at Peterlee New Town and his collaboration with Richard Hamilton on *An Exhibit* in 1957. This was one of the first British environmental exhibition installations and followed up pre-war Constructivist ideas. Pasmore's belief that modern art should come to terms with technology also has pre-war connections, but his way of putting it into practice undoubtedly had particular post-war relevance. He also expanded the notion that it is not necessary for a work of art to be unique or even made by the artist's own hand.

Pasmore's example in turning to abstract art was immediately followed by a group of pupils and friends: Adrian Heath, Kenneth and Mary Martin, Terry Frost, Anthony Hill, of whom the Martins and Hill went on, like Pasmore, to make relief constructions and with him formed the basis of a new English Constructivist movement. Much of Pasmore's thinking in this respect was sparked off by a chance encounter with the American artist-aesthetician Charles Biederman's *Art as the Evolution of Visual Knowledge*. Biederman believed that the future of abstract art lay in relief, since two-dimensional painting must always have recourse to illusion in representing space.

However, although in the reliefs of the later fifties and sixties Pasmore adopted a more Purist attitude than before he was not concerned with any rigid kind of aesthetic. His approach has always been empirical rather than scientific, his interest in a non-Euclidean kind of geometry, and while making relief constructions in terms of a machine aesthetic he also continued to paint two-dimensionally with freer, more organic forms, spirals, circular dotted areas of paint, freely drawn arcs and lines which look back to Mondrian and forward to Sol LeWitt. The tendency to amalgamate the

geometrical and the free form is already evident in the late figurative and early abstract paintings of 1947–50. Freely drawn spirals interlock as if solid forms and flatly geometrical triangles, circles and rectangles are juxtaposed with thin linear forms or freely brushed arcs and spirals.

It is perhaps the exploration of the organic properties of constant abstract forms like squares and circles which has been Pasmore's most important and influential contribution to post-war art. That and his emphasis on research. The understanding of form and colour function is the basis of his work as a teacher. In 1955 he developed the notion of research into basic abstract forms, their associations, spatial properties and colour analysis into a system of teaching which he first termed 'Basic Form', but later turned into 'The Develop-

ing Process'. Many of the artists who matured in the sixties were influenced by it. Bridget Riley is a notable example and the evolution of her simple geometrical optically-vibrant abstract painting from Pointillist and Futurist landscapes has close parallels with Pasmore's own development.

Arriving late, Pasmore had the advantage of age, reputation and a consciousness of continuity with earlier developments which young artists emerging at the same time did not have. At the same time he had the advantage of a much more open situation: Nicholson and Hepworth's work was already accepted and during the fifties British art was involving itself in some of the most important intellectual upheavals the twentieth century had yet witnessed.

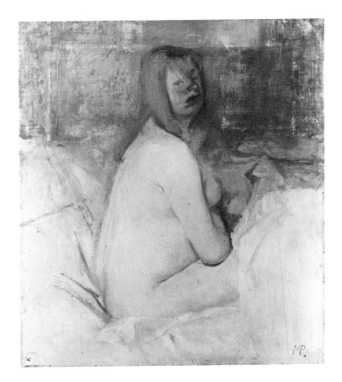

62 *Nude* 1941 61×51

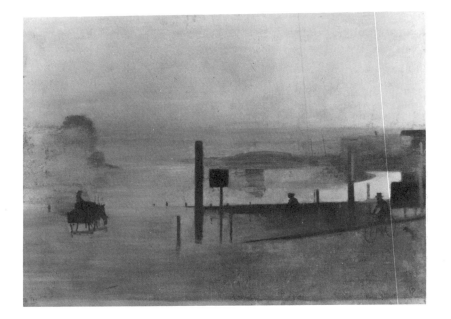

63 *The Quiet River: The Thames at Chiswick* 1943–4
76×101.5

67 *Black Abstract* 1963 152.5×153×5

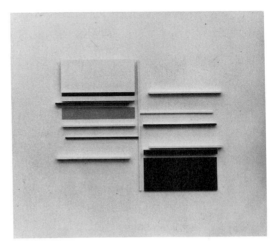

65 *Abstract in White, Black, Indian and Lilac* 1957
106.5×117×4

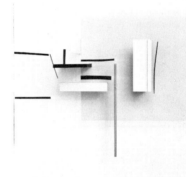

68 *Synthetic Construction* (*White and Black*) 1965–6
122.5×122.5×27.5

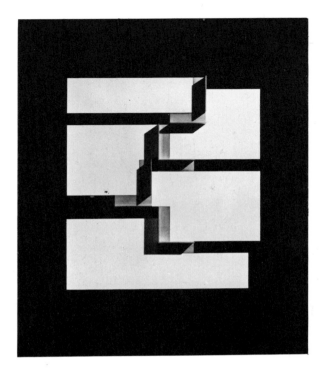

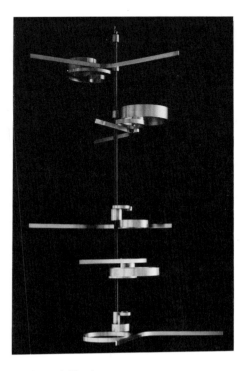

71 Anthony Hill
Relief Construction 1960–2 110.5×91.5×4.75

69 Kenneth Martin
Rotary Rings 1968 93.5×58.5×58.5

70 Mary Martin
Spiral Movement 1951 46×46×9.5

64 *Square Motif, Blue and Gold: the Eclipse* 1950 46×61

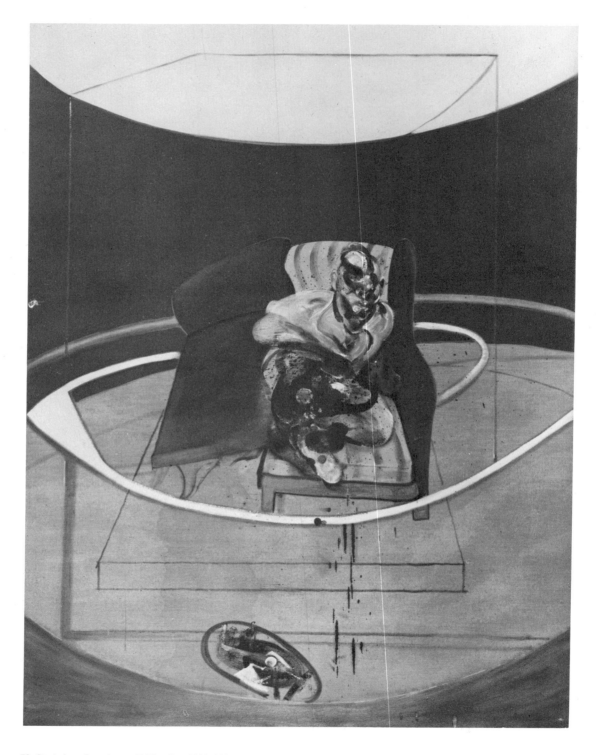

78 *Study for a Portrait on a Folding Bed* 1963 198×147.5

Francis Bacon (1909)

innovative

Francis Bacon's career had a strangely delayed beginning. He aroused the admiration of some notable people interested in avant-garde art in the thirties (for example Michael Sadler and Herbert Read), he had one or two small one-man shows and took part in a few group exhibitions, but he did relatively little painting and for long periods none at all. Around 1930 he was perhaps better known as an interior decorator.

But although the years up to 1943–4 may have been more devoted to living and watching than to art, a number of interests relevant to the post-war work were established then: for instance he was fascinated by the Soviet cinema; he bought a book of diseases of the mouth for its beautiful colour plates; he began to collect photographs from books, newspapers and magazines—the kind of media exposing all sides of behaviour which was to develop into a flood after the war.

One of the abiding things about his work has been its feeling for the time when it was made. The few surviving pre-war pictures, despite his status as a self-taught artist, show a remarkable grasp of Picasso's work, while Bacon's interest in modernism is everywhere apparent in his style as an interior decorator. However it was all, even the Crucifixion reproduced in Herbert Read's *Art Now*, rather lightweight beside the force of the images he began to complete in the middle of the war when asthma stopped his attempts at war work and when he suddenly found painting had become obsessively important to him.

The three *Studies for Figures at the Base of a Crucifixion* were shown alongside works by Graham Sutherland at the Lefevre Gallery in London in 1945. Sutherland had painted *Horned Forms* and was thinking about the Northampton Crucifixion, but his vision must have seemed mild and romantic indeed in comparison. This was a world where humanism and a sense of great traditions were flooding back, the horrors of war were being tidied up, deserts meted out and the atrocities swept under the carpet. Bacon's images seem like an ugly reminder of the ancient, repetitive, futility and malignance of it all, though we can be sure he intended no message. He was simply stating the fact of his image as he grasped it, and it probably came to him through day dreaming or unconscious scanning. The mixture of conscious and unconscious characterizes all his work. Apparently he conceived the three figures as the Eumenides, the Greek furies. The transposition of mythological and Christian subjects, their temporal appropriateness and their semi-human form provide a 'Verfremdungseffekt' similar to Brecht's. And the notion of a parallel with the human image, rather than a direct illustration of it, underlies Bacon's approach to painting from then on—even at its most naturalistic it fulfils the modern requirement of having a sense of criticism built into it. These three figures emerging from a single sketchy line of drawing twist against the front plane of the firmly vertical-horizontal structure of the composition in a way which foreshadows the twisting energy of the figures

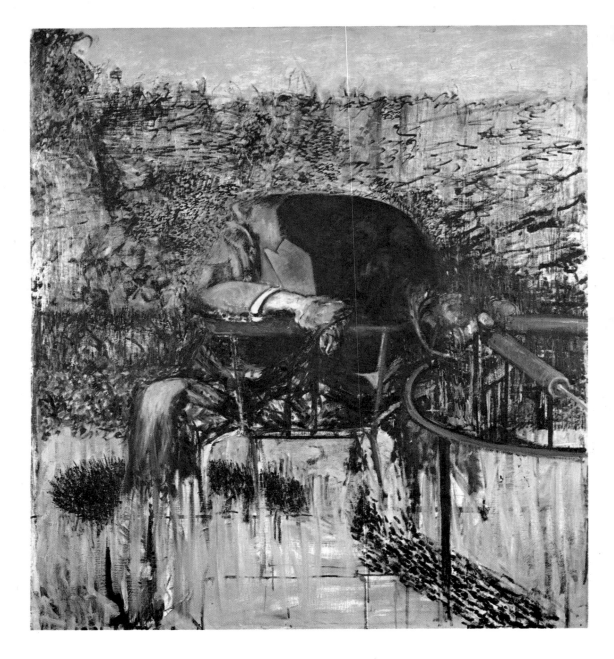

73 *Figure in a Landscape* 1945 145×128

of the late fifties and sixties, which seem so much paint-constructed images caught on the wing that they exist without conventional boundaries.

The sensational elements which have given Bacon the reputation of being a painter of violent subjects perhaps have their origins in the more general subject matter of this time (much of it lost and destroyed). Army uniforms, black automobiles, potted palms hint at photo- and cinematographic origins. The images are fragmentary, Surrealist and dream-like, but essentially conceived in a realistic style. The Tate's *Figure in a Landscape* is a good example; it is typical that what started as a man dozing in a deckchair in Hyde Park should have turned into a headless thug casually raking the observer's space with a machine gun. But though there is a continual sense in Bacon's work, violent or not, that safety can turn to danger, that the animal is fierce or the man can kill, the sensational subject is rare after 1950; he became more closely involved with the possibilities of the human figure in detail and with portraiture.

The paintings of the forties set down other lasting preoccupations for the first time: the man in the chair, tubular steel furniture, the Turkey carpet, window blinds with dangling cords, two sides of beef, that standard Surrealist property, the umbrella. The soundless scream Bacon used so often in the forties and fifties, which he took from the Nurse with broken spectacles in Eisenstein's *Battleship Potemkin*, also appeared as early as 1945.

Yet at this time all these things tend to be juxtaposed in a classical Surrealist kind of way—their deliberate disquieting incompatibilities hold the composition together, but in an essentially fantastic invented way. Then at the end of the forties and in the early fifties Bacon adopted a unified, more naturalistic approach. He tried combining two recognizable images within a single form—Velasquez' *Innocent X* with the Screaming Nurse. Or he created a half-animal, half-human head emphasizing man's affinity with animals which is rarely totally absent from his paintings. (The subject was also, of course, very much in the air at the time for Moore, Sutherland and many young sculptors.) Simultaneously (and more generally important) Bacon also developed a much more realistic approach centring round the human or animal quite alone in its situation, occasionally two figures, but usually one, sometimes disregarding, sometimes apparently communing with the spectator.

The fifties saw established most of the remaining themes Bacon has worked with: the single and double figures lying on a bed, the portrait, the self-portrait and the row of three studies of the same head or figure, the animal in landscape and in a cage. For the moment the complex multi-image picture is abandoned and two main things appear to occupy him: realism and modern life on the one hand, based largely on photographs, and paintings based on earlier works of art. Somehow the paintings are more secluded in the fifties. Two nude men wrestling in the grass or making love on a bed seems a more private image than a man sitting on the lavatory in the sixties.

Many of Bacon's images, such as the two men wrestling, have their origins in Eadweard Muybridge's studies of people and animals in motion. In other cases Bacon has used cinema stills and photographs from newspapers and magazines. A book called *Positioning in Radiography* has been a profitable source for bandaged and strangely positioned limbs. And it isn't just the image that may be relevant, Bacon is also interested in the odd and arbitrary processes by which form is conveyed

through colour printing, which links him with figurative artists of a younger generation such as Andy Warhol or Richard Hamilton.

However, in all cases Bacon will combine his use of photography with memory and observation. He has said, 'In my case photographs become a sort of compost out of which images emerge from time to time. These images may be partly conditioned by the mood which has gone into the pulverizer.'

The kind of camera which records the strange and revealing minutiae of human behaviour is closest to Bacon—and where he is closest to Muybridge. There is a continual tension in his work revolving round the contrast between the dispassionate observation of behaviour in general and the appearance and behaviour of particular people, especially a few friends. Images slip from the identifiable to the unidentifiable, emphasis slips from the general to the particular and back without boundaries.

Bacon sees himself essentially as a reporter in his attitude. The image he produces is not finite or descriptive except in terms of the conflict between life and itself. And here it tells more clearly than any conventional portrait what it is like to be alive today.

Bacon's portraits are always of friends or of himself. More often they are done from memory than from life and if he has a sitter he may refer more to a photograph than to the person. Of painting people closest to him he has said he likes to be alone with their memory. Many of them such as Lucian Freud, Henrietta Moraes, George Dyer and Isabel Rawsthorne have been painted numerous times.

It is no doubt significant that while Bacon was approaching portraiture as a subject in the fifties he was also exorcizing an obsession with one of the greatest portraits in the world—Velasquez' *Innocent X*. However, it is not enough to say that Bacon's portraits are in the tradition of the great state portraits. His work covers portraiture at all levels, from the unknown man eating a leg of chicken to a named friend riding a bicycle, or three studies of the artist's own head at different angles and three distinct readings of personality. Bacon has unquestionably been the leading resuscitator of portraiture in our time. He has given portraiture back the status it had in Rembrandt. He has done without the official and transcends the documentary. In 1966 he said that the difficulty of painting portraits was such in present conditions, that the portrait had replaced for him the mythological or religious subject as the most taxing form of painting.

His interest in past art, from which he has frequently drawn, is significantly the art of painters who have been great observers and who have also handled paint superbly, but in a very controlled way: Velasquez, Goya (the formal portraits), Degas, Seurat, Constable, Rembrandt, Van Gogh.

It is almost a cliché to quote Bacon as saying he wanted 'to paint like Velasquez, but with the texture of a hippopotamus skin.' He is totally committed to the medium of oil paint and applies it in many unorthodox ways, with a squeegee roller or rubbed with an old jersey. Around 1949–50 he had begun to handle paint in a more sensual and in a more contrived way than in the early forties, working as much for the sake of the paint as for the sake of the image. During the forties and fifties, among various illusionistic painterly devices, he frequently adopted the practice of painting large areas with long vertical brush strokes; sometimes these formed curtains, sometimes they were background and sometimes the image seemed to peer

through them as they formed a front plane or grid behind which the three-dimensional form was built up. Sometimes they physically cut into and blurred the image. Each picture would use the paint to suggest a number of different sorts of illusionist space and different angles of perspective.

In 1956–7 at the time of a series of paintings after Van Gogh's *The Painter on the Road to Tarascon* Bacon began to paint much more freely. Many of these pictures were done in a hurry for exhibition and the paint is sometimes used in a raw kind of way he has not repeated, nevertheless it may have been through them that he found the way to the handling of paint which characterized his work during the sixties. It is already visible in the reclining figures of the end of the decade. Against areas of flat, brilliant colour paint is used for flesh in a way that suggests the artist is creating his image through a living substance, that he is always ready to exploit the medium as it gives ground, to seize hold of and take advantage of the accidental. Talking of a self-portrait by Rembrandt in Aix-en-Provence he said, 'I think the mystery of fact is conveyed by an image made of non-rational marks.' From this time there is a new kind of tension between the paint and the image, and within the image between the paint marks themselves.

The image which Bacon presents from the late fifties on also has its spatial definition built into it through drawing, through silhouette. The background to the figure may be a totally flat band of colour, but the figure itself seized at an angle, as if in a fleeting instant, will be ruthlessly pinned down in that pictorial space.

Bacon has said, 'I'm not a preacher. I've nothing to say about the human situation : what gives the pictures their desperate look if they have one, is the technical difficulty of making appearances at the present state of the evolution of painting.' These figures might be regarded simply as stylized if the elements by which they are built up were unknown, but these are what enable him to convey fact in a non-illustrative way.

Bacon's assault on the factual image has grown enormously during the sixties. Apart from portraits he moves through the world of everyday—men shaving, sitting on the lavatory, reading a newspaper, reclining half nude on beds and sofas, riding a bicycle ; pictures painted with love and compassion, charged with eroticism, always structured, always rational, increasingly ambitious.

He has gone back to the full-scale composition involving several figures often in the form of a triptych. (And at the same time to something of his earlier Surrealist juxtapositions of images.) Two are Crucifixions, another involves a different kind of murder—it is based on T. S. Eliot's poem *Sweeney Agonistes.* But in either case the two categories mingle. There are sexual images, bloodied beds and bodies, onlooker images in all of them. It is always Bacon's intention to walk the tightrope between narrative and pure painting. He shows the underlying themes of life, but on top of them are layers of mystery expressed in terms of the preoccupations of today. The origins of the images can be as widespread as Cimabue, *Positioning in Radiography* and Harrod's Meat Department.

Although Bacon has had no specific stylistic successors he has probably been the biggest single influence on British figurative painting since the war. He did what Moore and Nicholson and Hepworth did for abstract art and the figure in sculpture : he laid the ghost of Roger Fry and of Cubism. He made it possible to paint the figure again and not just in portraiture—

something grander. The work of Graham Sutherland, Richard Hamilton, R. B. Kitaj, David Hockney, Allen Jones, to a greater and lesser extent has demonstrable affinities with his paintings and perhaps some of them gave something back.

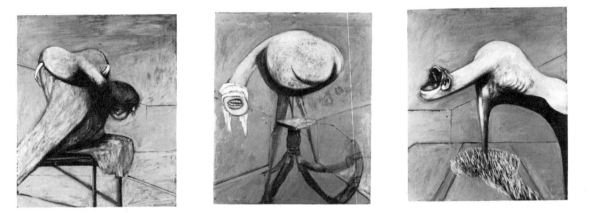

72 *Three Studies for Figures at the Base of a Crucifixion*
c. 1944 each 94×74

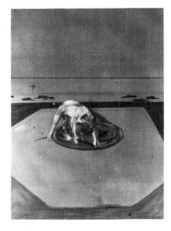

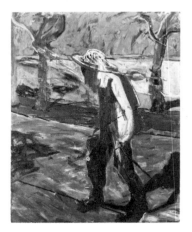

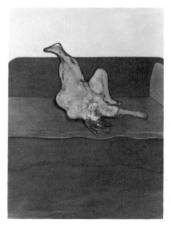

74 *Study of a Dog* 1952 198×137

75 *Study for a Portrait of Van Gogh IV* 1957 152.5×117

76 *Reclining Woman* 1961 199×141.5

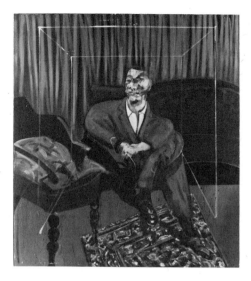

77 *Seated Figure* 1961 165×142

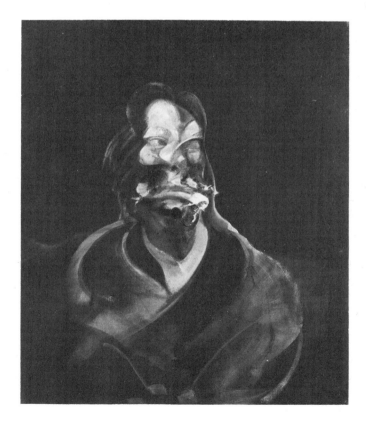

79 *Portrait of Isabel Rawsthorne* 1966 81.5×68.5

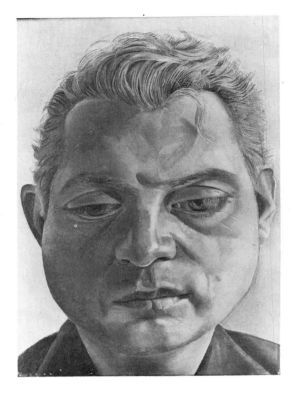

87 Lucian Freud
Francis Bacon 1952 18×13

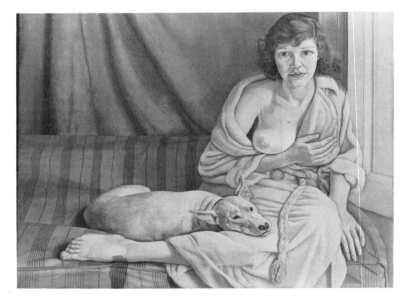

86 Lucian Freud
Girl with a White Dog 1950–1 76×101.5

The Forties and Fifties

The end of the war brought the end of isolation. There were big exhibitions of Picasso, Matisse, Klee, Braque and Rouault and young official organizations took over where private individuals had struggled in the thirties. The Arts Council which had begun to spread culture nationally during the war continued to expand its activities. The British Council presented British Art abroad starting with Moore, Nicholson and Hepworth and was soon sponsoring newer directions. Herbert Read was a ubiquitous figure on committees. Large *catalogues raisonnés* would shortly begin to appear. On a more Bohemian front, and more congenial to the young generation, the Institute of Contemporary Arts became a vital communications centre in the fifties.

Face to face with world art a brief wartime hot-house flowering of neo-Romanticism collapsed or readjusted itself. Yet it had contained elements which were not irrelevant to the post-war situation. The emphasis on mood, emotion, state of mind and bodily sensation which characterized art of the next fifteen years had there an early rather uncontrolled, sometimes clichéd expression, but by means largely irrelevant to current art concerns. There was little consideration of art as a continuously expanding historical and cultural commitment.

Of those associated with the group (Craxton, Minton, Colquhoun, McBryde and others) Lucian Freud is perhaps the only one whose work has continued in much the same way. But then he had adopted a way of working which more or less eschewed style. At first his Van Eyckish approach (now rather looser) may seem outside the preoccupations of the fifties. He seizes emotion through the dogged process of minute construction and intense scrutiny. But the psychological and close-up aspects of it are totally post-war, though they have their roots in the thirties. Francis Bacon (a close friend) and Giacometti had the same problems and expressed them by something of the same tussle of execution. These are human beings under the microscope, existing rather than acting, demonstrating what it is to be a human being as body plus mind, the one driven by the other and vice versa. Although they may be portraits they are not idiosyncratic personalities seized from the outside as in a portrait by Graham Sutherland. The artist doesn't aim to depict characters, he depicts real objects— take it or leave it. They reveal themselves more slowly.

After the war Nicholson and Hepworth stayed on at St. Ives and made it for a time a regional centre of international relevance, a place associated with a contemplative humanistic life with a basis in the observation of nature. And in the late forties and fifties many young artists were attracted to it: Lanyon, Wells and Wynter were or became permanent residents; Pasmore, Scott, Hilton and Heron were summer visitors or lived there on and off.

Many of these artists (born before 1920) had lost a good deal of time in the war and were getting their careers under way rather

belatedly. And as we shall see at the same time a still younger generation was developing almost simultaneously, with rather divergent convictions.

Peter Lanyon's story begins before the war. His painting and the Cornish landscape were inextricably mixed. He was born and lived all his life in St. Ives and his relationship with the land from whence he came was tremendously important to him. He was perhaps saved from parochial self-immolation by early contact with Adrian Stokes and subsequently with Nicholson, Hepworth and Gabo in 1939. Under their influence Lanyon gave up painting for a time in favour of constructions. However, apparently this was a practical decision rather than *Schwärmerei*. His landscapes had become 'wild, messy and dispersed' and he needed to re-examine the technical problems of painting. Furthermore he wanted to get away from painting landscape from one position only, to escape the ties of conventional perspective.

He continued to make constructions as a preparation for paintings throughout his life, and when he returned to painting after war service he did not return to painting about things seen naturalistically, nor indeed solely about things seen. The new paintings contain ideas of, for example, fertility and generation, literary abstract metaphors, combinations like mining and giving birth, contraction and expansion—all very much related to the vision of Adrian Stokes as aesthetician with their parallels in New York School painting. And literary references continue while Lanyon went on to paint landscape-based subjects in the fifties. The story of Europa is mentioned more than once (a story which also appealed to Pollock as it had to Rubens). Some landscapes can be read figuratively, like *Porthleven*, 1951, or they may be based on a structure which is more mysterious, an allegory such as the Europa story providing him with a kind of Duchampian Geometry —a system to which chance and the artist hold the key. But though they may be inspired by a knowledge of the shape of the countryside seen from the air or felt from the ground, basically the content of these paintings is purely abstract, evolved out of a making of marks in a certain way on the surface of the canvas. Lanyon wrote in 1952, 'My source is sensuous . . . plastic form is arrived at not by modelling with *chiaroscuro* and fixed perspective, but by sensory paint manipulation . . . My art follows Constable—it is to be found in the hedgerows.' It is created out of the tensions between the paint and the image, imagination and reality, object and process.

Lanyon went to New York for his first exhibition in 1957 and found himself more successful there than in England. He got to know Kline, Motherwell, Gottlieb and Rothko, and in later years his handling of paint became more fluid. However, it is doubtful if New York painting was ever an effective influence. His development arose from parallel concerns.

To William Scott, the modern movements in painting in the thirties seemed escapist, too far removed from the social and political pressures of the time. Most in sympathy with the Euston Road painters he looked instead towards earlier art and to Bonnard, Gauguin, Modigliani, Rousseau, Matisse. Living in Paris and Pont-Aven before the war he was in time to know such historical figures as Emile Bernard, Maurice Denis and André Derain.

After the war Scott joined the group of painters living in and visiting St. Ives motivated by a great respect for Ben Nicholson. Scott had no liking for neo-Romantic tendencies and continued a pre-war direct kind of painting based on the classical range of

82 William Scott
Ochre Painting 1958 86.5×112

everyday still-life objects. Simple, without being conventional or trickily stylized, the black iron frying pan, the eggs, the bowl of fish have the same sharp focus of Dylan Thomas's images. (And Scott, in fact, knew the poet well.)

Then between 1949 and 1952 Scott increasingly became concerned with the formal aspects of painting. Objects and table, or a nude figure perhaps, remain as scaffolding, but Scott was pushing towards pure abstraction. Victor Pasmore had got there, so had some of the Constructivists, also Roger Hilton and Adrian Heath. It was beginning to look as if a new identifiable strain of abstract painting was emerging in England.

In 1952 Scott was experimenting with fluid gouaches which are almost completely abstract (rather as de Stael's landscapes are almost abstract and de Stael was then becoming very popular among English painters). But a visit to America the following year, while it revealed new possibilities in terms of scale and colour also threw into relief Scott's sense of his place in the European tradition. Seeing the Lascaux caves in 1954 revived his interest in primitivism and he moved back for the moment towards the earlier symbolic realism, but incorporating a new painterliness and energy.

Roger Hilton's work has a rawness and directness about it ('I have a taste for plain pictures') which has earned him the respect of the younger generation. A frequent visitor to Paris, he first began to paint abstract paintings under the influence of Klee, then in 1950 came in contact with the work of Mondrian and Constant. In 1953–4 his paintings were among the most abstract and advanced in England, however he soon abandoned trying deliberately to keep them that way preferring to work with rather than against his materials.

Although the paintings have specific references, to sexual imagery or to landscape for example, they are concerned with recording feelings direct, not with illustrating accepted topics. He has written: 'Painting is feeling. There are situations, states of mind, moods which call for artistic expression because one knows that only some form of art is capable of going beyond them to give an intuitive contact with a superior set of truths.' In the simplicity and straightforwardness of his means of expression he may have acquired something both from primitive art and from Matisse. In spite of apparent connections, he developed apart from American artists, his work is dryer and not so suave as Motherwell's, for instance, nor so bucolic as de Kooning's. It is with the European tradition that it seems closest, Beuys might perhaps be a parallel, but Hilton's work is acutely objective in its subjectivity and never mystical.

Patrick Heron is getting on for ten years younger than Scott and Hilton, but he has been bracketed with them although his interests are closer to the generation of abstract painters born after 1930, with John Hoyland for example. He is more interested in colour, space and light in their existences and interactions observed in an objective though non-scientific or systematic way, than in the complex problems of human identification which concern Hilton or Lanyon.

In 1953 (the same year that Matisse created his great abstract *papier découpé*, *L'Escargot*, a circle of blocks of pure colour) we find Heron organizing an exhibition called *Space in Colour*, for which he wrote a catalogue introduction that attempted to define colour's role in pictorial space and emphasized the dialogue between illusion and surface played by colour in abstract painting. (Pasmore, Hilton,

Frost and Scott were among those included.) Paris orientated until the mid-fifties, by 1957–8 Heron was doing pure abstract colour paintings using colour in ways superficially close to Rothko, Newman, Louis, Still, Reinhardt and others of the New York School. They contain a debt to these artists, but also enough differences to make it clear that he had arrived at the same objective state.

The story of the younger generation of abstract artists, Cohen, Denny, Hoyland, Riley, Smith, belongs chiefly to another chapter. Many young painters reacted against landscape-based abstraction. They wanted something more precise, which could be read clearly and on its own terms, but without the scientific overtones of Constructivism. They built a new vocabulary out of the marks they were using which had no one-to-one reference with the outside world or to the artist's subjective feeling. Thus they had a somewhat different goal.

They were already committed to abstract art, they didn't need to come to terms with it. However, the development process was not always smooth. For example, Bernard Cohen left the Slade in 1954 and spent an unsatisfactory period in Europe; he did not escape the vague informal approach of Abstract Expressionism until 1959, greatly assisted by the example of Barnett Newman and by Existentialist philosophy. Richard Smith and Robyn Denny found ways round the problem by combining lessons of communications and games theories and the mass media with the sensuous professionalism of New York School painting. The development of a figurative art tuned to similar ideas also belongs to another chapter.

It took longer for new sculpture to emerge after the war. Adams, Armitage, Butler, Meadows, Chadwick did not begin to make characteristic work much before 1950. In fact two younger figures were rather ahead of them: Eduardo Paolozzi and William Turnbull.

In general the first generation of postwar sculptors reacted against the emphasis on carving which had characterized much of the sculpture of the previous three decades. They turned instead to Picasso and Surrealism, to an art which was convulsive, human and fragmented. (Though it was not a movement confined entirely to the young, Henry Moore's work had both led the way and moved with it.)

Herbert Read saw the new sculpture in Jungian terms of an agony of snares, teeth and claws, which in retrospect seems somewhat overdone, and too literal a reading. If Eliot was the poet of the time we should see things more allegorically. (Though it is true these were the years of humanity in close-up and in detail.) Moreover many of these young sculptors were lumped together at the Venice Biennale of 1952 in a way which denied their different characters.

Reg Butler's achievement in the late forties and fifties was that he began to expand the potential of wrought and welded iron. Through the example of Picasso and of Gonzalez in France, close to Calder and parallel with David Smith in America, he produced a more open kind of work with an important rawness of material which took sculpture another step away from the notion of the monolith. Though more recently he has returned to the ancient erotic art of modelling the female figure.

Chadwick's man/bird/animal figures, his watchers, were regarded as rhetorical by a younger generation seeking a purely abstract expression. However, they have close connections with Moore, Bacon and Paolozzi in their sense of metamorphosis and Kafkaesque imagery.

Armitage in the fifties was involved in a more social kind of sculpture. He attempted to seize some of the swiftnesses and feelings rather than the monuments of life. Figures are joined together, as in a crowd where 'we don't see mathematically, but only what is most conspicuous or important or familiar.' His multiple figures are people who 'hurry to and fro, struggling against adverse winds seeking urgently each other's companionship.' Although Armitage is not primarily occupied with the human figure as seen in detail by another human figure, the human figure is the basic module on which he works and the variations are slight, as in Giacometti's sculpture, and in the same way they make a world of difference.

One of the most important sides of Paolozzi's education lay in Surrealism. First as a student in London at the end of the war, where there was plenty available at Peggy Guggenheim's and E. L. T. Mesens' galleries, and then in Paris. He lived there on and off for three years from 1947 and got to know Braque, Arp, Léger, Giacometti, Brancusi, Dubuffet and especially Tzara. Grass has never been known to grow under Paolozzi's feet.

His work of the time seemed very different from Henry Moore's, though the latter's attitude was also changing. The Surrealist and natural forms Paolozzi used are not so far from Moore's work of the thirties, but they have a brutalism which Moore did not have. They are also indebted to Picasso and to the Musée de l'Homme, while *Forms on a Bow* of 1949 crosses mechanical and natural elements in a way which is close to Klee, but more forceful

On Paolozzi's return to London he shared a studio with Turnbull, whom he had known at the Slade, and he was also meeting Francis Bacon frequently. From 1952 he became deeply involved with the activities of the Independent Group at the Institute of Contemporary Arts. Here in a semi-intellectual atmosphere he expounded his long-standing interest in mass media imagery, Art Brut and all kinds of visual information systems. Following Picasso's famous Baboon Paolozzi began to incorporate an incredible multiplicity of everyday objects into his sculpture, as a kind of cast collage, seemingly packing back all the surface excrescences Brancusi had expunged, but on a simple formal basis. The figures of the period are totems, humanoids, robots connected with horror film inventions like Frankenstein. It is but a short step to the mechanical forms of the sixties, though the fragmented surfaces are close to César, Richier, as is the note of magic and ritual. What is new is the irony and the powerful sense of humour.

Turnbull and Paolozzi have many interests in common, chief among them being a liking for the direct, natural and immediate, and a dislike of connoisseurship and High Art. With Richard Hamilton they were among the first who saw the activity of the artist as a practical urban profession which should reflect everyday experience. The main difference in their work is that Turnbull, though influenced by Surrealism and Giacometti, was not interested in the Surrealist notion of the object, but in more abstract issues of form, space and function. Turnbull's concern is with an anti-precious art, perhaps even with movable parts for the spectator to handle, which can have both an everyday unimportantness and a sense of magic derived from primitive art. His work has a pervasive quality of stillness and heightened consciousness which, though it relates to American art of the forties and fifties, for example by Barnett Newman, is largely outside the general run of English art of the same time; it is nearer, perhaps, to the

work of Richard Long in the sixties. In his interest in both popular imagery and abstract art his attitude is close to Smith, Denny and Long, and his interest in archaeology is similarly based. His sculptures suggest idols, but outside time. Like Brancusi, Newman, Pollock and Long, Turnbull is preoccupied with ancient traditions and attitudes and how they shed light on the present, but there is no nostalgia for past things in his work.

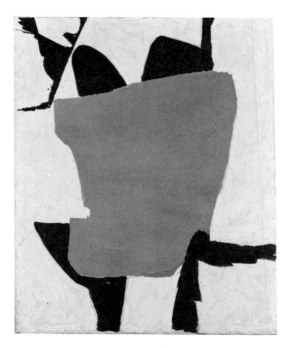

80 Roger Hilton
Painting February 1954 279.5×152.5

85 Patrick Heron
Horizontal Stripe Painting 1958 279.5×152.5

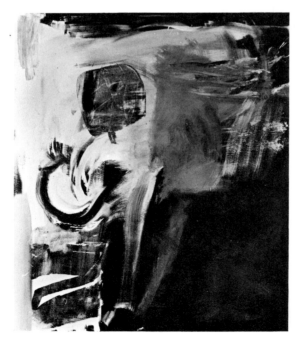

84 Peter Lanyon
Thermal 1960 183×152.5

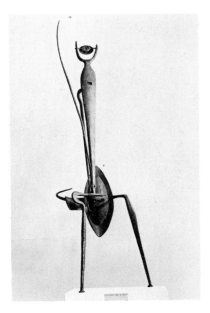

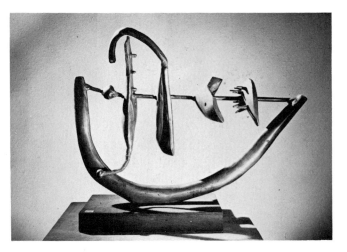

89 Eduardo Paolozzi
Forms on a Bow 1949 48.5×63.5×21.5

81 Reg Butler
Woman 1949 221×71×48

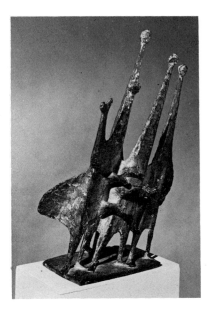

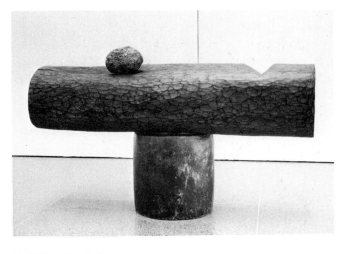

88 William Turnbull
Spring Totem 1962–3 90×148×43

83 Kenneth Armitage
People in a Wind 1950 65×40×34

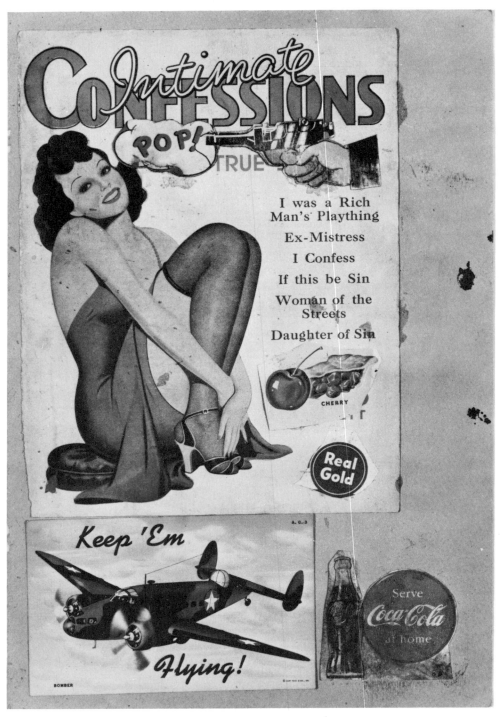

90 Eduardo Paolozzi
I was a Rich Man's Plaything 1947 35.5×23.5
(Collage from "Bunk")

A New Approach to the Figurative Image

By 1947 Eduardo Paolozzi was making collages from mass media material which he regarded as 'art', though they remained in the scrapbooks in which they were made until 1971. They extend the compulsive scrapbook-making he had been involved with since childhood.

The primary art influence on these collages was the Surrealist work he saw as an art student in London and then in Paris in 1947–9, especially that of Duchamp, Ernst and—through magazines—John Heartfield. This fused with his admiration for sex and cinema magazine images, comics, food and automobile ads., which he felt described the world of dreams better than any conventional art language.

Paolozzi's interests came into the open in 1952 at the second meeting of the Independent Group at the Institute of Contemporary Arts. He gave a 'talk' consisting of a weird and massive presentation through an epidiascope of found images from both technological sources and popular media. The first (1952–3) season of the Independent Group, organized by the architectural historian and critic Reyner Banham, was concerned with bringing outside modes of thought into art, in the event chiefly from science and technology. And the result was the photographic exhibition *Parallel of Life and Art*. The second season, run mainly by the art critic Lawrence Alloway, was devoted to popular culture as opposed to highbrow culture : violence in the cinema, car design, consumer goods were lecture topics. It was during this period that the term 'Pop Art' as distinct

from fine art was adapted from the trade term 'Pop Music'.

Yet the number of artists playing an important part in these meetings was still very few—notably Paolozzi, Richard Hamilton and William Turnbull. And none of them had yet developed an obviously 'Pop' kind of art. Turnbull's work became less geometric more anthropological with magic overtones. Paolozzi's figures, though encrusted with found city material, were still made in bronze and primitivistic. Hamilton's pictures in the early fifties, though preoccupied with technological devices and sometimes specifically modern imagery, are straight if rather minimal paintings with references to Klee, Futurism and Cubism and a strong interest in the photographs of Muybridge. Hamilton was concerned with making and contributing to a number of mass media exhibits from the 1951 *Growth and Form* exhibition, which was specifically modern, but in terms of scientific techniques and images, through *Man, Machine and Motion* (1955) to *This is Tomorrow* in 1956 which had full-blooded Pop environments as well as more highbrow references. But it was not until after this last exhibition, for which he produced the famous collage poster *Just what is it makes today's homes so different, so appealing ?*, that Hamilton began to explore the possibilities of mass media imagery and communications in painting.

This is Tomorrow demonstrated that urban life contained myths on an epic scale, quite as powerful as the antique

myths which had provided painters with their subjects in the past. But even more vital perhaps was the potential in the transfusion of languages and conventions and technologies from non-art contexts. The prime concern in the mass media is impact and readability and the methods had much to teach the artists. Equally important was the way in which the image was received. The reader of advertisements and comics, the cinema goer is consciously aware of his participation in a game. He takes pride in unravelling visual clues and noting the exaggerated claims made by the advertiser for his dream world product; while he is taken in by it, he also is conscious of the deliberately tinsel and cardboard effect of the whole thing. The inhabitant of a modern consumer society is thus continually concerned with an extraordinary interplay of reality and fantasy, with professional art forms and human longings which reflect them and are reflected in them.

The Cubists, the Dadaists, the Futurists, Picabia, Duchamp, Picasso had already made a start in this direction and in combining many kinds of art and non-art references and techniques in a single picture. The machine aesthetic of Le Corbusier, Ozenfant and Moholy-Nagy pointed the same way. What was happening was one of the processes of bringing art up to date which occur every so often. Certainly by the end of the war, with the exception of a few older artists like Stanley Spencer and Edward Burra, the figurative image in Britain was not in a particularly lively state. Potential figurative artists, Moore, Sutherland, Coldstream even, were concerned with figurative images in a mainly abstract context or in terms of perceptual relationships. The neo-Romanticist and Kitchen Sink School painters tried new wine in old bottles. New blood was pro-

vided by the lone figure of Francis Bacon whose photographic borrowings, sinister gangsterish references and rather filmic atmosphere homing in on everyday objects like a tweed coat or a black roadster, were up-to-date and fantastic at the same time.

The Independent Group artists were not entirely alone in their interests. A group of slightly younger like-minded painters was emerging at the Royal College of Art. Joe Tilson was producing romantic lithographs of calypso singers incorporating their names and addresses as early as 1953. He later turned to hardcore Pop imagery, to carpentry, games theory and *Scientific American* mathematical puzzles for sources. Richard Smith was a leading influence in his appreciation of the mass media, of consumer goods, the visual techniques of selling them, and above all the techniques of photography—film and still—even before *This is Tomorrow*. But his contribution has been in breaking the barriers between non-fine art and abstract art and is discussed in the next chapter.

Peter Blake's earliest known pictures from the beginning of the fifties, before he went to the Royal College, are not very different from those done ten or fifteen years later, which makes him one of the earliest known users of Pop imagery. However, his sympathies and concerns are entirely with the things he paints and nothing to do with the morals and ethics of adopting a new art form. His allegiance is to the combined imaginary and real worlds his characters inhabit—true like the Beatles or invented like Dr K. Tortur the wrestler, or literary like Puck or Alice or the Mad Hatter —rather than to an aesthetic idea. Though he uses aesthetic and painterly devices almost with abandon.

Perhaps it is the rigorously non-art attitude, the lack of an axe to grind, the use of real material, the straightforward approach

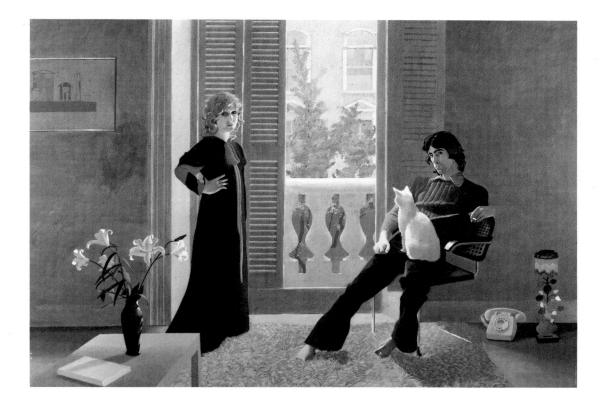

106 David Hockney
Mr and Mrs Clark and Percy 1970–71 213.5 × 366

to painting combined with dazzling shifts of time and space in his collages, the wealth of detail in his paintings, part glamorous, seedy, nostalgic, real life, part fantasy about life, which make him particularly interesting to younger artists. There seems to be a strong link between Blake and Gilbert and George in the tightrope they walk between art and life.

A third group of connected artists studied at the Royal College in 1959–63. These included R. B. Kitaj, Peter Phillips, Allen Jones, David Hockney, Derek Boshier and Patrick Caulfield. Their preoccupations and attitudes are rather different from earlier generations since there was now no need to be dogmatic or moralistic about non-art references. Though they still had their ability to shock in the early art school stages, already before they left Pop images had become fashionable, part of 'swinging London'.

What connects Kitaj, Hockney, Jones, Caulfield and to some extent Boshier (though he has changed direction since) is that they are primarily interested in painting, though they also make use of ready-made images in compiling new and personal iconologies with references beyond the merely Pop. An American with a wide and varied education who came to live in London, Kitaj works on the intellectual Left Bank of figurative art. His work was perhaps the first to contain references outside both the Pop-media and visual ethnographical sources. Kafka, Norman Douglas, Dostoyevsky, Isaac Babel, Rosa Luxembourg come in among others. At the same time Kitaj probably had a wider knowledge of contemporary American painting from Abstract Expressionism through to Johns, Dine, etc, than any of his contemporaries at the Royal College. But for all that Kitaj has lived in England his style and vision have retained something American. There

is a sense of horror, unpleasantness in his works which English painting never achieves, something nearer to Kienholz than to Bacon. Portraits have the sinister look of Identikit pictures rather than friendly photographs. Other pictures contain not just expressionist overtones of fetishism, madness, sex or death, but of thought gone wrong, intellect perverted by unreason and animalism more specific and relevant to contemporary life than any Surrealist art.

His influence on Jones and Hockney has been freely acknowledged. Jones described the fascination of 'the way he uses the potential of a scribble, but what looks like a scribble in his drawings was very slowly and carefully constructed'. This notion may have connections with the way Jones builds up a chain of semi-automatically conceived ideas, which start life in notebooks, rather like a visual diary, and gradually move into the paintings.

Hockney has said that through contact with Kitaj for him the abstract-figurative battle ceased to exist. He came to understand that it was no longer necessary to paint on the whole of the canvas and that many different kinds of marks could be made on it including drawing. And his work has continued to include as part of its subject an exposé of the ways images can be painted, from the graffiti on public lavatory walls to the styles of ancient Egypt, from the graphic conventions used to portray the reflections of glass, or of light on water, to photographic realism.

Allen Jones's pictures also involve shaped canvases, rapid swings between illusion and abstraction; like Hockney's they are half about painting itself. Where Hockney has a figure peering through a plane of perspex tacked to the front of the picture, imprisoned within the picture surface, but making painty handprints on the perspex, Jones may paint a pair of highly

modelled legs in the sketchiest pair of high-heeled shoes standing on a real ledge.

Like Hockney, Jones has evolved an iconography of his own which in some senses is a kind of serial story about his life, his imagination and what he sees. There may be references to Nietzsche, mail order catalogues or Varga's pin-ups or tribal erotic art, but there are also recurrent symbols which have a particularly personal reference and reappear in many contexts: the two figures, male and female which elide joyfully into a hermaphrodite, the tie which is a masculine symbol and the explicitly feminine high-heeled shoes.

Hockney (like Jones and before either of them, Bacon) also frequently paints love in his pictures. The double figure composition has obsessed him for more than ten years. His paintings are about friends and places he knows: 'I paint what I like, when I like and where I like with occasional nostalgic journeys . . . I am sure my sources are classic or even epic themes. Landscapes of foreign lands, beautiful people, love, propaganda and major incidents (of my own life) . . .'.

Like David Hockney, Patrick Caulfield does not regard his work as Pop Art. Nevertheless he shares the same concern with an image which puts over its message in the directest possible way, and with the mechanics of how it performs that feat. His characteristic black outline drawing was sparked off by touched-up postcards of Knossos purchased in 1961, rather than some kind of advertising technique, but the result is analogous in impact.

Concern to present things immediately gives the images he paints a peculiar sense of significance. Very often focus is on one thing only—a ring, a house, a bowl of flowers. Objects are particularized as though they exist, but not in terms of space. Caulfield aims to introduce a fragmentary

feeling while making his images circumstantial.

He treats references to established traditions of art (fine and non-fine) rather as Richard Smith has used advertising images and techniques of photography and printing to give a fresh sensibility to making paintings and an extended sensibility to looking at them. His subjects include quotations from Cubism and a transposition of a painting by Delacroix. He may use a photograph from a museum publication about Turkish pottery or a tourist trap postcard. He adjusts and heightens awareness of a well-known image or type of image by transposing it into an unexpected painterly context.

Howard Hodgkin draws his subjects even more directly from the world around him. He too has sometimes, much more unjustifiably, been lumped together with his generation of so called Pop Artists. In some ways his work is close to Richard Smith's, but though it refers to artifacts it has a relationship with the space and light of the real world closer to Matisse before the *papiers découpés*.

Hodgkin's paintings are always based on a scene observed at a particular moment in time. It is a moment of clarity immediately recognized by the artist, not something remembered after the event. For example *Dinner at West Hill* commemorates a party at Bernard Cohen's house which Hodgkin has described as 'a nervous and glittering evening in a green and white room' with a number of small paintings by Cohen on the wall.

Hodgkin is obsessed with artefacts, such as objects in people's houses, and with his pictures as objects. And while the paintings are composed of very formal ordered marks on a flat surface, as in Indian miniatures (on the subject of which Hodgkin is an expert) they are also views and contain

quite complex illusionism. They frequently contain mirrors or paintings, as in the work of Matisse or Vermeer, both of whom were also engaged with the problem of rendering the minutely observed situation in terms of abstract construction.

92 *Meet the People* 1948
Collage, 36×24

93 *It's a Psychological Fact
Pleasure Helps Your Disposition*
1948 36×24.5

91 *Lessons of Last Time* 1947 36×24.5

94 *Sack-O-Sauce* 1948
35.5×26.5

95 *Real Gold* 1950 35.5×23.5

96 *Windtunnel Test* 1950 25×36.5

97 *Yours Till the Boys Come
Home* 1951 36×25

98 *Was This Metal Monster
Master—or Slave?* 1952 36×25

99 *The Ultimate Planet* 1952 25×30

Eduardo Paolozzi
Collages from 'Bunk'

100 **Peter Blake**
The Fine Art Bit 1959 91.5×61×2.5

102 **R. B. Kitaj**
Isaac Babel riding with Budyonny 1962 183×152.5

105 **David Hockney**
The First Marriage 1962 183×214.5

104 **Derek Boshier**
Identi-kit Man 1962 183×183

107 Allen Jones
Man Woman 1963 366×198

101 Howard Hodgkin
Dinner at West Hill 1964–6 42×50

103 Patrick Caulfield
Battlements 1967 152.5×274.5

111 Robyn Denny
Garden 1966–7 244×198

Abstract Painting and Sculpture in the Sixties

When Robyn Denny wrote in Ad Reinhardt's obituary in 1967 that Reinhardt 'believed in the possibility of achieving not a communication in art, but a communion', he might well have been talking of himself. He was certainly speaking for many of his generation. His paintings don't shout their messages and then turn their backs, they depend on the participation of the spectator to reveal themselves in dialogue little by little.

Denny's ideas about participation have their roots in the fifties, when he was a student at the Royal College. By the time American painting as shown at the Tate Gallery in 1956 came to mirror the younger generation's need to escape the conventions of abstract landscape pictures, Denny was already concerned with getting art back to reality. In 1956–7 his works incorporate real materials, acts, mosaic, burn marks, scraps of paper and pure painting.

His use of written language, collaged, stencilled, juxtaposed with passages of pure paint was evidence of his interest in theories of communications, and everyday media—a concern which was also shared by a number of his associates, for instance, Richard Smith. These were also ideas emanating in great force from the group based at the Institute of Contemporary Arts.

There was tremendous scorn among the followers of New York Painting, and the critic Lawrence Alloway in particular, for the painters of the St. Ives School. A relevant art was an urban art first and foremost, and essentially an art of a consumer society. And not merely a consumer society, but a participatory society which was engaged professionally, politically and ideologically. A society which juggled daily with all kinds of complex signs and messages and where artists had a professional role to play.

The notion of participation lies behind a series of transformable works Denny made in 1959 and behind the small environmental exhibition called *Place* to which Richard Smith and Denny contributed. Following the environmental nature of Rothko's work and the traditional notion of paintings for specific places, the pictures in this exhibition aimed to make something with a physical presence that would transform and animate the space they occupied. They were man-sized and free-standing, in a zig-zag maze formation. Both of these examples reflected Denny's interest in the theory of games.

Denny was not interested in transferring the images of the mass media into painting. What concerned him were the structures and systems which these images obeyed. In language and communication he saw a parallel with painting and concluded it could be interpreted and practised as a language. Towards the end of the fifties his interest in the act of painting and in concrete materials was superseded by the act of perception: the rules and relationships which structure reality. From 1960 Denny began to work with perceptual symmetry and an emblematic structure which emphasize the role of the entity on the wall as a painting. But these paintings

are man-related, generally upright in proportion and hung at ground level. Like Giacometti's sculpture they involve the spectator in direct confrontation. We are not involved with a hieratic presence, but with another being who shares our space. The symmetry and the simple divisions of the canvas have no meaning without the participation of the spectator in a way similar to work by Andre, Stella, Judd or LeWitt. Denny is one of the first of recent artists to work on the principle that the work of art looks back at the spectator (as in Giacometti or Michael Craig-Martin's Mirror pieces). A number of Denny's early paintings are based on head-shapes, but later it is the proportions of the standing human figure which take over the role.

Like Denny, Richard Smith was also involved with mass media communications, but in a rather different way and with a more specific reference. Such parallels were there 'to bring a fresh sensibility to making paintings and an extended sensibility in looking at paintings.' He did not know the personalities involved in the early years of Pop Art at the ICA though he heard about their activities from Lawrence Alloway. But in Richard Hamilton's *Man Machine and Motion* exhibition, *This is Tomorrow* and Marshall McLuhan's *The Mechanical Bride* he found confirmation for his own cultural interests. He wrote for the Royal College of Art Magazine on films, modern jazz and rock and roll and in the mid fifties used blow-ups of beach scenes as a basis for pictures though his way of painting was a two-inch brush stroke close to de Stael. Contact with the sensuousness of New York painting in 1956 was equally important. The paintings after 1957 combine a new fluidity and softer brush-strokes with the techniques of photography, especially photographic focus. From 1959 to 1963 Smith lived in New York, the

Mecca of mass media culture, and during that time began to make three-dimensional paintings often with a direct reference to packaging or billboards. However the excitement of widespread Pop activity in the early sixties has somewhat overbalanced the view of Smith's painting on the side of the reference to the product—tissue, cigarettes—rather than the means or multiplicity of messages. The impact of photographic and cinematographic techniques, billboard and cinemascope scale, the falsity of printed sources which revealed the mechanics of communication, the whole ambiguous business of seeing— these seem to have been what interested him most. Recognition of the original functions of forms gives another layer of appreciation and maybe a quick way into the paintings, but the images are deliberately clouded by shadows, painterly tricks, off-register colour, drips, edges where there are none, voids where maybe there should be solids.

Smith, like Oldenburg, was involved with the larger than life, with the more real than real. In the early sixties he did paintings on a big scale which referred to hand-held objects: out of context or in close up the scale of things is especially ambiguous, they can be both pills and boulders. Similarly by bringing what is specifically a painting into the spectator's space Smith retains the essential falseness of the picture. He heightens awareness of the frailties of visual and tactile sensitivity. These are some of the ways Smith established the swing between reality and non-reality, the true and metaphorical, the real and imagined. Having the painting in actual space gives it a beginning and an end in reality.

By 1964–5 formal problems were more or less self supporting. The package had become a box nothing to do with adver-

tising, but rather something which could be bent apart, changed physically. A rectangular module. What tautly stretched canvas could do revealed itself as he went along, for example the idea of butting a number of units together and using their edges as drawing in the work didn't materialize until 1966–7.

Around this point, while producing works which have their obvious (though indirect) connections with Minimal Art Smith was also beginning to look again at the possibilities of more direct handling. Although he was to continue his logistically complex and very large pictures for some time he was already beginning to think in terms of cut and folded paper as much as of boxes. And he was soon to become interested in paint as a substance which would change the canvas from canvas to being something silken, earthy or towel-like. A new more factual surface that went beyond what colour alone can achieve in terms of reality.

Most recently he has taken the picture off its wooden stretcher substituting a light backing similar to a kite, and has taken to sewing the paintings together in various ways. Whatever he does is not unrelated to what has gone before, but that he never avoids current ideas is always manifest.

In many ways Bernard Cohen's work is close to Robyn Denny's. Both artists produce works which reveal themselves slowly to the onlooker, both display a preoccupation with light in their paintings. Both (independently) used forms rising from the canvas edge like an archway. Like Denny, Cohen's imagery in the late fifties and early sixties refers to culture outside art—in this case to hotels and restaurants, shops and cinema architecture, Art Nouveau and Art Deco—he too was anxious to escape from the prevalent English landscape abstract tradition. But although he is akin to Denny in that the subject of his paintings is not the phenomena they recall, Cohen differs from Denny in that all his work is a complex meditation on the activity of painting.

His concern is with the process and illusionistic character of individual marks, with awareness of the physical surface on which he works and with the identity and function of each layer of paint he puts on. From the weave of the canvas through the single drawn line to the topmost layer of paint, each has a function. The sequence of actions performed is rendered visible in the painting, and is part of its subject.

Unlike Denny's his art is thus mainly gesturally based, a smear of paint, a sprayed area, a dogged blobbing with white paint each involves a different process, it may involve a difference of scale and a difference of time. Between 1958 and 1962, Richard Morphet reports in his catalogue of Cohen's 1972 exhibition at the Hayward Gallery, Cohen was obsessed with bull-fighting; it was something where every gesture counted and could not be gone back on, where everything was visible and nothing could be faked. This interest in ritual is common to many artists. For example it relates to Barry Flanagan's interest in making works which are the subject of their own processes and more recently in dance, as much as to Pollock's drip paintings. Cohen, like Turnbull and like Pollock, has been fascinated by the rituals and styles of ancient cultures. Many artists in the fifties and sixties have found carrying through a rigorous sequence of actions a way to avoid the rhetorical gesture, the mannered element they saw in the landscape abstraction they reacted against. This is not to say that Cohen's paintings are dry or unemotional; what is interesting about them in this respect is that they do

112 **Bridget Riley**
Late Morning 1967–8 228.5×359.5

not illustrate visual impressions or nostalgic emotions—they convey states of mind.

Bridget Riley is concerned with the elements of painting in another way. Her approach was perhaps sparked off by the exhibition *The Developing Process* by Victor Pasmore and Harry Thubron at the Institute of Contemporary Arts. It drew her attention to the fact that any element involved in painting had an identity and a potential which should be explored. It is capable of certain things and incapable of others.

A late developer it wasn't until 1959–60 that she began to construct paintings in terms of optically vibrant colour relationships and to dissect the emotional problems of colour and line after Seurat, the Futurists and Klee. But by 1960 she was much concerned with what the painters like Denny and Hoyland were doing, and she did herself paint a few hard-edged abstract pictures. Finally in 1961 she painted her first black-and-white painting using the two colours as polarities, for their absoluteness. And at first she stuck to black and white only coming to full colour, via tonal gradations of grey, in 1966.

She harnesses traditional emotional properties of line and colour in a non-traditional but essentially non-scientific way. The emotions her pictures convey are empirically conceived and the mathematical side of her work is confined to simple progressions, adding, halving, quartering. Nor has she studied the science of optics. Although she is acquainted with the work of the Groupe de Recherche d'Art Visuel she is far from following their example.

John Hoyland's concern is with colour—in terms of mass—delineated enough to define shape—and the substance of colour. He uses colour emotionally as he needs it, but there is a structure of reasoning behind the instinctive process of painting. And a complete commitment to what is personally appropriate and necessary. Contact with Victor Pasmore's idea of Basic Form rationalized what Hoyland had been trying to do intuitively, though up to 1959 he continued to need a starting point in reality. Reacting against Abstract Expressionism in 1960 he began to work with juxtaposed bands of colour, but he was more interested in the action within the picture than in the confrontation between spectator and painting, which concerned Robyn Denny. However by 1962–3, feeling his paintings were becoming too formal, he went back to reconsider the ideas about space and shape and illusion which characterize his present work. His concern was to find a form of drawing which would relate neither to the organic forms of Arp nor to the divisions of the canvas of Barnett Newman. By 1965 he had developed a positive relationship between figure and ground and had also escaped from an earlier kind of inventive drawing. More recently he has begun to use paint in chunks and the shadowy illusionism of the relation between units and ground from the period around 1965 is exchanged for areas of paint which form huge barriers spread like butter in front of a ground, activated into a diorama of colour, involving a much more complex physical reading of paint as substance.

Hoyland and John Walker seem recently to have been mutually influential and both surely owe something to the American Hans Hofmann. Walker was early concerned to escape from the single colour saturated canvas and to bring all kinds of activity into his paintings and for each kind, collage, drawing, impasto to be recognized for what it was. The emphasis in his work on the activity of painting is in the keyed-

up tradition of Soutine, Pollock and
Bacon: seizing, exploiting, expressing an
idea with both hands. Recently Walker has
been doing wall-drawings in chalk which
are emphemeral, almost pure activity, they
stay on the wall for the duration of an
exhibition and are painted out.

Although painting may have been a little
in front of sculpture in 1959, the gap was
very soon closed when Anthony Caro be-
gan to make coloured steel sculptures in
the spring and summer of 1960. Before
Caro visited the United States in the
autumn of 1959 he was producing bronze
figures, heavily modelled, owing something
to Henry Moore and to Matisse, expres-
sionist, but with patches evoking an in-
tense observed realism.

In America Caro was impressed by the
work of the painters Noland, Morris Louis
and Pollock, he saw at least one sculpture
by David Smith and also met him. At
the same time he renewed his acquaint-
ance with the critic Clement Greenberg.
The steel pieces which followed this trip
were made by bolting and welding large
sections of steel together and painting the
whole. Where Caro's work differs from
Noland's is in the way he makes a work not
out of a single image, but out of a number
of parts all of which combine to produce a
unified series of emotions. The same is, of
course, true of David Smith, but Smith is
still essentially concerned with making an
image which is monolithically unified. A
mysterious personification or object in-
vented by the artist. Caro's sculptures are
not identifiable as objects so much as con-
structions which create mental and physi-
cal sensations in the mind of the spectator.

The early steel pieces have a junkiness
and a fortuitousness in their assemblage
which has connections with the beginnings
at Art Povera (the art of unimportant
materials) and with the general current of

urbanism. The tradition in which pieces are
simply assembled not physically moulded
into a single form starts with collage and
African art and finishes up with Process
Art. But most of all it is important to see
that these sculptures are assembled in
terms of decisions, or even propositions;
does it work? What has he done? What
has he not done?

Although the generation of Long and
Gilbert and George and Victor Burgin saw
there was nothing in steel sculpture for
them, they often considered the same
questions. They were certainly concerned
above all with decisions of what to put in
and what to leave out. More mundane—
the relation of Caro's work to floor or land-
scape in 1965–6 is almost as direct as
Long's and his work is extremely minimal
and by implication easily removable at this
stage. The way it runs along the ground
marking out for itself an elegant place in
natural surroundings is close to Long's.
Moreover Caro's work has no pretensions
to grandeur and is often geometric in
shape.

But as Long's work grew increasingly
complex and conceptual in terms of time
and space, Caro took a course closer to
that of Robert Morris, Phillip King and
others, in which art is physically experienced
by moving around and through it as well
as in terms of visual sensation: about the
time of the *Primary Structures* exhibition in
New York Caro's work became larger and
more pictorially evocative. Yet at the same
time, like many artists who have not been
prepared to turn to words and photographs,
he has laid emphasis on the object quality
of sculpture, from a pair of scissors to a
rubbish skip. While making the work a
little less lyrical he has given it character as
a dumb presence in the spectator's space,
but the initial impression gives place to an
even greater complexity of detail.

How we see Caro's sculpture depends on our ability to register and analyse the nature of our physical and mental response. The response is provoked by colour, by a notion of an over-all image and by the role of each of its parts. The side of the image which refers to the real world resists any precise reference; it is evocative because a balance is held between the visual reality of the elements and the physical and mental experience of the sensations aroused. One can say the same of paintings by Robyn Denny or Bridget Riley. Victor Burgin uses a similar kind of self-analysis as a basis from which to take perceptual understanding one stage further.

One of the most often remarked features of this kind of sculpture is that it is placed on no stand-offish pedestal, it stands right there in the spectator's space. Thus it should be noted that William Turnbull had already abandoned the convention of the base as early as 1954. Turnbull's work in the sixties differs somewhat from Phillip King's or Anthony Caro's in that he allows his manufactured materials, beams, pipes, wattle fences, to express their own characters in a much more obvious way. Even in the painted pieces the material is evident, hard and steely, and colour is used factually rather than expressively. While in the Totem sculptures he often used contrasting materials: stone, plaster, wood, emphasizing the inert or characterless or living quality of each.

A number of younger sculptors moved into the field of abstract coloured sculpture, many of them directly inspired by Caro, his enthusiasm or the dynamism of his teaching at St. Martin's School of Art, if not directly by his work. Where Caro often used ready-made elements the younger men—Tucker, Witkin, King, Bolus, Annesley—tended to give their work a skeletally geometrical construction, or used a progression of geometrical shapes and their derivatives. Repetition, proportion, growth suggested through sequence, metamorphosis or the process of making were some of the means employed. Though their sculptures inhabit our space like furniture, are often open in construction rather than monolithic, the work can seem intangible in the blandness of its steel, fibreglass and painted surfaces. But colour dematerializes and gives energy to the form suggesting that colour itself is tangible. These sculptures discuss the nature of a three-dimensional visual experience and make it a lyrical and metaphorical one. Sadly, owing to lack of space, we can only show a minimal amount of this kind of work in the exhibition.

Phillip King found the surface hardness of Caro's metal sculpture rather repelling at first. He was by nature a modeller and looked for a more direct relationship with his materials. He too had been working figuratively, influenced by Michaelangelo, Moore and Richier, until he moved into the abstract field in 1960–61. His emphasis has been much more on materials and the nature of materials, at first cast concrete, then wood and plaster, then fibreglass and now steel, but not in terms of their individual essences—rather of what they can do. His interest is in exploring concepts like fluidity and solidity, inside and outside. In fact these are things which Moore had begun to think about, but not so abstractly nor in colour. King's work is also akin to Moore's in the element of personification some of his earlier works acquire. The appearance and subject of the sculpture has a greater element of mystery than of scientific exploration. Colour gives it another field of play and also holds it together emotionally. What gives the image its individual, organic quality is the activity of the artist, twisting, cutting, fitting

bits together. This was something which found a kindred spirit in Barry Flanagan, as did the superimposition of a geometrical form upon a fluid situation.

Although for much of the sixties Paolozzi was heavily involved with graphics he also made a good deal of sculpture. His term as Visiting Professor at the Hochschule für bildende Künste in Hamburg was influential. Germany (seen through the spectacles of Fritz Lang) fitted in with Paolozzi's idea of modern society: it no longer seemed to have a fine art tradition, it was a technological, ruthlessly modernistic society. More practically the shipbreaking yards and steel works pro-

vided him with raw materials for many sculptures. Rough surfaces disappeared and references were to machines more than animals or humanoids, though still with a sense of personification.

Returning from Hamburg he began to make pieces constructed partly of stock machine units and partly of made-up elements, with the whole thing put together by skilled craftsmen under Paolozzi's direction. Moholy-Nagy's famous painting ordered by telephone is an obvious connection. *Rizla*, ironically referring to a well-known brand of cigarette paper, is just such a piece.

114 **Bernard Cohen**
A Matter of Identity I 1963 244×244

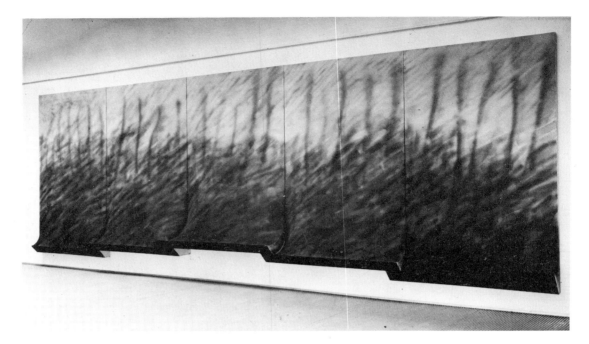

113 Richard Smith
Riverfall 1969 228.5×686×35.5

115 John Hoyland
17.3.69 1969 198×366

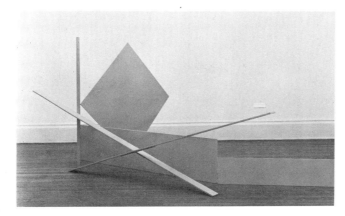

108 **Anthony Caro**
Yellow Swing 1965 179×198×397.5

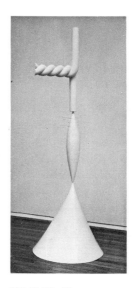

116 **Phillip King**
Tra-la-la 1963
274.5×76×76

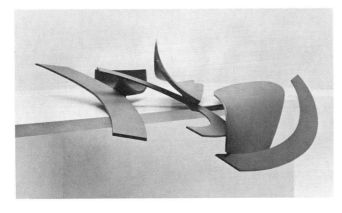

109 **Anthony Caro**
Piece LXXXII 1969 44.5×120.5×146

110 **Eduardo Paolozzi**
Rizla 1965 165×211×150

119 **Barry Flanagan**
Pile 1968 32×52×48

New Developments

Such was the excitement generated by the falling barriers between painting and sculpture and abstract and figurative art, that onlookers at first failed to realize the importance of certain other attitudes which developed almost simultaneously.

Not long ago it would have been unthinkable for a museum of art to buy works consisting of maps, everyday objects, photographs or printed words, not arranged or collaged for aesthetic effect, but partaking of their normal functions and composed as the result of pre-determined non-aesthetic processes. Today we can see how such works, some of which have been banded together under the heading of Conceptual Art, are related to older traditions.

It may be significant that many of the first and formost artists concerned with developing needs which could not be satisfied by sculpture in metal and fibreglass came from St. Martin's School of Art where Anthony Caro headed the Sculpture Department. At the time when the post-Caro 'New Generation' of sculptors trained at St. Martin's was bringing its coloured sculpture into the public eye in 1965 a feeling had already been born that artists needed to work outside the limitations of already established models and to find a wider range of materials and images. It was, of course, an international preoccupation: Andre, Morris, Smithson, Heizer, Oppenheim, in America, Dibbets in Holland, Long in London were all arriving at the same objective state and during the next few years beginning to solve the problem by moving outside a studio context.

Richard Long had already established his direction in 1965, even before he went to St. Martin's. His first pieces out of doors, depressions dug in the ground, were done that year in Bristol, but it was while he was a student in London that he began to make works which included an extended perception of time and space, and which drew together and defined the different and specific actions involved in the process of making them and their relation to the time-scale and place in which they were made. The whole world suddenly seemed open to work with.

Long's art is characterized by its privacy, by its purity and by the strength of its visual imagery, which is based on the confrontation of a specific place and a simple abstract form—circle, rectangle, cross, triangle, straight line. Instead of changing the shape physically, as Barbara Hepworth might do, he imposes it whole upon the chosen site. The two things fuse, yet their separate identities remain distinct. The location imposes its modulations upon the geometrical form to produce a perfect shape which is also a kind of cast of the place, an image in its own likeness.

Working indoors one way he creates an interpenetration of images is by transferring elements from his own environment to a gallery situation—for example in 1968, sticks from woods near Bristol went to a gallery in Düsseldorf. Out of doors he may simply rearrange the landscape for a limited time and record the action photographically. The similarly structured photo-

graphs and maps which record his actions without producing the physical evidence for our inspection—as in the *Hundred Mile Walk*—have been viewed more suspiciously. But it is here that Long makes his most radical contribution. Based on ordinary everyday systems of reference which we can easily decode: maps, photographs, a few brief printed sentences, they contain perspectives beyond the wildest dreams of conventional sculpture. Not that Long is interested in an expanded scale in terms of size, it is the potential switches and juxtapositions of time and space, speed and terrain which are so astonishing in a traditional context.

Hamish Fulton's work also has the feeling of an essentially private activity. The traces of the artist are there in the juxtapositions and the final choices that make up a work, in the stringent selection of images and view points, in simple actions such as the pebble thrown to emphasise the horizontal plane of a lake. Unlike Long, Fulton more often maintains contact with the landscape he works with by the acts of passing through it, climbing over it and peering into it through the camera, rather than by physically rearranging it.

But like Long, Fulton is concerned with producing a physically, mentally and visually telling juxtaposition of images. The meaning of the work lies in the way the images created by the simplest most direct means—i.e. photographically—affect and change one another. In the way that juxtaposed they suggest, very powerfully, a structured three-dimensional situation. Various devices are used to produce this. For example, a piece may be structured round a particular walk, or a climb over a particular terrain and distance. A particular time span may be involved. The artist aims not simply to state the facts of what

he has seen correctly, but to present the essence of an idea.

Richard Long was a close friend of Gilbert and George at St. Martin's and their attitudes have much in common, though Gilbert and George emphasize the privacy of their lives by publicly making them the subject of their work.

They began to work together while still students in 1968, starting their process of amalgamating art and life in their first show, which consisted of sculptures on tables in a sandwich bar down the road from the art school. They first performed their *Singing Sculpture* to the tune of *Underneath the Arches* in art schools, rather later going on to Pop world venues such as the Lyceum Ballroom and Plumpton Pop Festival. They did a piece which involved a long series of personal visits amounting to an investigation of all aspects of the art world, which parallels the investigations which render visible the social systems of contemporary life by Haacke, Graham or Huebler.

At the same time Gilbert and George have made works which document themselves in more permanent ways: drawings, photograph pieces, poems, postcards related to their preoccupations, videotapes, texts describing the relation of their lives to art, drawn up to look like gigantic charters. Many of their works concern one of their favourite activities: the consumption of alcohol. (A traditional art subject.) *Gordon's Makes us Drunk*, a videotape to the tune of Elgar's *Land of Hope and Glory*, reveals them imbibing freely in private disguised as a macabre television commercial. *Balls or the Evening Before the Morning After* shows them getting progressively drunker in one of Messrs Balls' Wine Bars in the City of London.

Their art and their lives are interchangeable and they are thus able to insist 'We

don't *do* pieces. We just show some small parts. They're not even important.' Or 'We've come to see art as a great big history of our personal relations, of day by day changes.' Nevertheless they seem to take enormous pride in the professional execution of both their art and their lives, and many of their pieces (like their living) are *tours de force* of physical endurance in a way which echoes Long's long walks or Hamish Fulton's running and climbing pieces.

As the power of Long's sculptures lies in the spark struck by the conjunction of an abstract form and a specific place, so too the force of Gilbert and George's work is engendered by the physical juxtaposition of art and life.

Though essentially a lone figure in this context, John Davies' sculpture contains many of the currently discussed paradoxes concerning the interchangeability of those two areas. Working in the tradition of Kienholz, and others, Davies produces an at first sight uncannily realistic effigy, which is then observed to have in place of features a strange mask, an animal's skull, or a bird. Or a neat, but shabbily suited, figure will be involved in some strange unspecified action, perhaps kneeling or crawling on the floor. The surreal, halucinatory effect at close quarters of these figures inhabiting the same space and scale as the spectator leads him to a feeling of physically entering a world where the unconscious becomes fact and can lead to madness or to death.

Two other artists who were at St. Martin's at the same time as Long and Gilbert and George are Barry Flanagan and John Hilliard. Both produce work in which the process of making it is an integral part of its structure.

Flanagan has made object sculpture, environmental installations and films, but his way of sizing up the feel of a place and of juxtaposing the relative simplicity of a geometrical shape and a fluid situation has much in common with Richard Long.

Flanagan's sculptures often have a somewhat surreal element of personage about them, but their look cannot be separated from the way they were made, and the forces which produce the works are real forces, not frozen imitations. The elements of his pieces are the subjects of the pieces and the titles often signal the end of a course of action: rack, pile, etc. Materials tend to be specifically unimportant, things that can be dumped down, scooped, poured, wrapped. There is a distinct sense of ritual about the making which is common to many of these artists. The compulsion to make has mysterious and deep seated origins, but the making must be objectively viewed.

John Hilliard's work since 1970 has been entirely with photographs, until recently centring closely round a particular technical action in photography and its variables. During the past year he has become more concerned with wider aspects of the subject—the relation of one image to another in narrative and speculative terms, as in *Across the Park*. Hilliard's pieces illustrate well how important and complex the self-referential aspect of art has become since abstract art first began to be 'about' art, rather than creating an image of nature. Hilliard uses photography to discuss photography, Long landscape to discuss landscape. The systems into which the materials are incorporated may be arbitrary or quasi-scientific, very often they will be self contained.

Since Cubism much importance has frequently been attached to materials which are unimportant or ephemeral, or suggest ephemerality. In the mid and late sixties the new wave of anti-materialism also

made itself felt in the arts, which at the same time were becoming more conscious of their political and social obligations. And though less effect was had on the art market than might have been hoped, the moral and physical results remain.

Victor Burgin's present work evolved (like John Hilliard's and Michael Craig-Martin's) out of Minimal Art and its radical reduction of incident within the object, which forced the observer to examine more closely aspects of his experience beyond the object. Instead of continuing to add to the apparently endless domain of objects, following his interests in philosophy Burgin turned deliberately towards a consideration of the way objects are conceptualized. And concerning himself with the observer he found he was no longer concerned with objects themselves, but events in the life of the observer.

His decision to work with language was also conditioned by the feeling that art was becoming economically determined, and secondly that in our present state of technology it was ridiculous to transport materials when one might transmit information.

It was essential that the language he used would be commonly understood, thus one of his first problems was to find a vocabulary of references which would be relevant to all observer situations. Part of the solution was to address the observer through an injunction directing his attention rather than by making a statement.

Beginning with the existence perceived and remembered of objects Burgin's more recent work has turned to a confrontation between memory, experience and knowledge of specific emotions. *Room* 1970 is an early written piece where the visual aspects of the work are very important. The spectator is led to compare his visual awareness of the room he is in (and in all cases the type of room, e.g. in an art gallery will have very specific connotations) with his knowledge and uncertainty of its substantialness, with his physical and mental experience of the acts of visual perception he is involved in and with other present and remembered and intuited bodily situations.

Michael Craig-Martin's work has many points of resemblance to Burgin's, but it retains the physical aspect of the art-object. His prime concern is with the ordinary function of things—object functions and human functions. Much of his recent work has concerned the physical function of mirrors to reflect, carry and pass images. At the same time it is vitally concerned with the spectator's attitude to confrontation, isolation, perception and behaviour with regard to a mirror image.

This idea of the function of objects and our habitual reaction to them is built-in to series of pieces which include the *Clipboards*, where ordinary objects, pens, pencils, clipboards, paper, etc, are arranged in various combinations. They can be visually read on an infinite number of levels according to their functions.

Their importance for Craig-Martin has a wider significance for the general trend of art. He has said they 'disengaged me from making sculpture, I wasn't interested in doing work that was verbally or mathematically based and although I don't think of the things I did as straight sculpture . . . I wanted to move away from that work without ceasing to deal with physical and visual concerns. I wanted to find a way of structuring other than by aesthetic composing, which is the basic weakness of post-Caro sculpture.'

Many of the same considerations have been essential to painters breaking through the conventions of their medium. Keith Milow and Stephen Buckley have both

developed an acute concern for process and material. Buckley in a way which relates to a physically complex painterly relation with the picture surface, and like Milow towards a superimposition of images and activities. Milow has said, 'I think I've always found it rather difficult to engage in straight painting, partly because I find the challenge has become rather too obvious and worn. I like to pose myself problems in terms of medium . . . I go through cycles of setting things up and bringing them together into an object or series of objects, at the same time running a parallel race with ideas.' The impact of his work lies in the alternately lucid and mysterious totality produced by the layers of process and reference from which it is constructed. Many of his works contain an in-built comment (characteristic of much twentieth-century art) on the nature of the work of art as such, and visual and titular references to other artists' works which have influenced him.

121 **Gilbert and George** (1943, 1942)
*Balls or The Evening Before the Morning After—Drinking
Sculpture* 1972 210.5×438.5

123 **Hamish Fulton**
A Condor 1973 59×84.5

125 **Richard Long**
A Hundred Mile Walk 1971–2 22 × 50

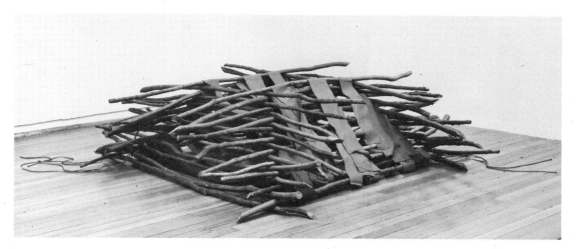

120 **Barry Flanagan**
No. 5 '71 1971 63.5 × 264 × 251.5

1
ALL SUBSTANTIAL THINGS WHICH CONSTITUTE THIS ROOM

2
ALL THE DURATION OF 1

3
THE PRESENT MOMENT AND ONLY THE PRESENT MOMENT

4
ALL APPEARANCES OF 1 DIRECTLY EXPERIENCED BY YOU AT 3

5
ALL OF YOUR RECOLLECTION AT 3 OF APPEARANCES OF 1 DIRECTLY
EXPERIENCED BY YOU AT ANY MOMENT PREVIOUS TO 3

6
ALL CRITERIA BY WHICH YOU MIGHT DISTINGUISH BETWEEN MEMBERS
OF 5 AND MEMBERS OF 4

7
ALL OF YOUR RECOLLECTION AT 3 OTHER THAN 5

8
ALL BODILY ACTS PERFORMED BY YOU AT 3 WHICH YOU KNOW TO BE
DIRECTLY EXPERIENCED BY PERSONS OTHER THAN YOURSELF

9
ALL BODILY ACTS DIRECTLY EXPERIENCED BY YOU AT 3 PERFORMED
BY PERSONS OTHER THAN YOURSELF

10
ALL MEMBERS OF 9 AND ALL MEMBERS OF 8 WHICH ARE DIRECTED
TOWARDS MEMBERS OF 1

11
ALL OF YOUR BODILY ACTS AT 3 OTHER THAN 8

12
ALL OF YOUR BODILY SENSATIONS AT 3 WHICH YOU CONSIDER
CONTINGENT UPON YOUR BODILY CONTACT WITH ANY MEMBER OF 1

13
ALL OF YOUR BODILY SENSATIONS AT 3 WHICH YOU CONSIDER
CONTINGENT UPON ANY EMOTION DIRECTLY EXPERIENCED BY YOU

14
ALL CRITERIA BY WHICH YOU MIGHT DISTINGUISH BETWEEN MEMBERS
OF 13 AND MEMBERS OF 12

15
ALL OF YOUR BODILY SENSATIONS AT 3 OTHER THAN 13 AND 12

16
ALL OF YOUR INFERENCES FROM 9 CONCERNING THE INNER
EXPERIENCES OF ANY PERSON OTHER THAN YOURSELF

17
ANY MEMBER OF 16 WHICH YOU CONSIDER IN WHOLE OR IN PART
ANALOGOUS WITH ANY MEMBER OF 13

18
ANY MEMBER OF 16 WHICH YOU CONSIDER IN WHOLE OR IN PART
ANALOGOUS WITH ANY MEMBER OF 12

117 **Victor Burgin**
Room 1970 (shortened version)

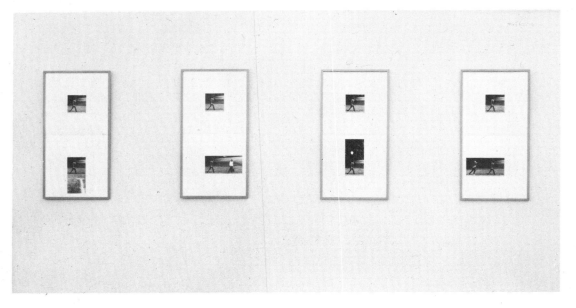

124 John Hilliard
Across the Park 1972 each 108×55

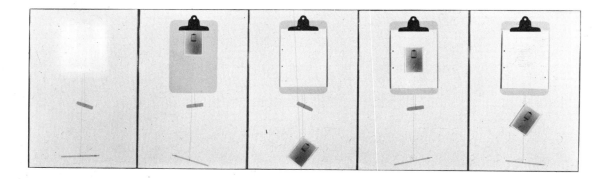

118 Michael Craig-Martin
4 Complete Clipboard Sets:
1. Clipboard
2. Sheet of paper
3. Pencil
4. Written Title
5. Eraser
Extended to 5 Incomplete Sets with Photograph Replacements
1971 each 77×51

122 Stephen Buckley
Nice 1972 81×91.5

126 Keith Milow
1 2 3 4 5 [6] B 1970 122×213.5×10

127 **John Davies**
Dogman 1972 28×18×26.5

128 **John Davies**
Head of William Jeffrey 1972 30.5×10.5×39.5

Catalogue

Measurements are given in centimetres, height precedes width

THE THIRTIES

John Cecil Stephenson (1889–1965)
1 *Painting* 1937
Tempera on canvas, 71×91.5

Edward Wadsworth (1889–1949)
2 *The Beached Margin* 1937
Tempera on linen laid on panel, 35.5×25

John Armstrong (1893)
3 *Dreaming Head* 1938
Tempera on wood, 46.5×78

Ivon Hitchens (1893)
4 *Coronation* 1937
Oil on canvas, 89.5×122

John Piper (1903)

5 *Abstract I* 1935
Oil on a collage of canvas on plywood
91.5×106.5

6 *St. Mary Le Port, Bristol* 1940
Oil on canvas mounted on plywood
76.5×63.5

Ceri Richards (1903–1972)
7 *The Sculptor in his Studio* 1937
Wood relief, with paper collage, ink, pencil,
strip brass and nails, 46.5×43×4.5

Edward Burra (1905)
8 *Wake* 1940
Gouache and watercolour, each 102×70

William Coldstream (1908)
9 *Mrs Winifred Burger* 1936–7
Oil on canvas, 78×54.5

Cecil Collins (1908)
10 *Cells of Night* 1934
Oil on canvas, 76×63.5

Rodrigo Moynihan (1910)
11 *Objective Abstraction* c. 1935–6
Oil on canvas, 46×36

PAUL NASH (1889–1946)

12 *Kinetic Feature* 1931
Oil on canvas, 66×50.5

13 *Pillar and Moon* 1932–42
Oil on canvas, 51×76

14 *Voyages of the Moon* 1934–7
Oil on canvas, 71×54

15 *Equivalents for the Megaliths* 1935
Oil on canvas, 45.5×66

16 *Landscape from a Dream* 1936–8
Oil on canvas, 68×40

17 *Totes Meer* 1940–1
Oil on canvas, 52.5×101.5

BEN NICHOLSON (1894)

18 *Auberge de la Sole Dieppoise* 1932
Oil, pencil and plaster on board, 93.5×76

19 *Painting* 1932
Oil, pencil and gesso on hardboard
74.5×120

20 *Guitar* 1933
Oil on panel, 83×10.5

21 *White Relief* 1935
Carved out of mahogany on plywood painted
white, 101.5×138.5

22 *St. Ives, Cornwall* 1943–5
Oil on canvas board, 40.5×49.5

23 *Feb. 28–53* (*Vertical Seconds*) 1953
Oil on canvas, 75.5×42

24 *August 56* (*Val d'Orcia*) 1956
Oil on masonite, 122×213.5

25 *Feb. 1960* (*Ice-off-blue*) 1960
Oil on masonite carved in relief, 122×183

HENRY MOORE (1898)

26 *Half-Figure* 1932
Armenian marble, 68.5×38×28

27 *Composition* 1932
African Wonderstone, 44.5×46×30

28 *Stringed Figure* 1938–40
Polished bronze with elastic string
27.5×34.5×19.5

29 *Four Forms, Drawing for Sculpture* 1938
Chalk, wash and indian ink, 28×38

30 *Reclining Figure* 1939
Bronze, 10.5×25.5×8.5

31 *Standing Figures* 1940
Pen, chalk and gouache, 26×18

32 *Grey Tube Shelter* 1940
Pen, chalk, wash and gouache, 28×38

33 *Tube Shelter Perspective* 1941
Pen, chalk, watercolour and gouache
48×44

34 *Woman Seated in the Underground* 1941
Pen, chalk and gouache, 48×38

35 *Pink and Green Sleepers* 1941
Pen, wash and gouache, 38×56

36 *A Tilbury Shelter Scene* 1941
Pen, chalk, wash and gouache, 42×38

37 *Shelter Scene: Bunks and Sleepers* 1941
Pen, chalk, watercolour and gouache
48×43

38 *Shelterers in the Tube* 1941
Pen, chalk, watercolour and gouache
38×56

39 *Helmet Head No. 1* 1950
Bronze, 33×26×25.5

40 *King and Queen* 1952–3
Bronze, 164×138.5×84.5

41 *Mother and Child* 1953
Bronze, 51×23×23.5

42 *Two Piece Reclining Figure No. 2* 1960
Bronze, 126×258×108.5

43 *Sculpture: Knife-Edge Two Piece* 1962
Bronze, 50×71×33

44 *Upright Form* (*Knife-Edge*) 1966
Rosa aurora marble, 59.5×57×24

BARBARA HEPWORTH (1903)

45 *Figure of a Woman* 1929–30
Corsehill stone, 53×30.5×28

46 *Three Forms* 1935
Seravezza marble, 20×53.5×34

47 *Single Form (Eikon)* 1937–8
Bronze, 120.5×28×26

48 *Landscape Sculpture* 1944
Bronze, 32×65×28

49 *Sea Form (Porthmeor)* 1958
Bronze, 77×113.5×25.5

50 *Image II* 1960
White marble, 75×77.5×48

51 *Hollow Form with White* 1965
Elm, white interior, 134.5×58.5×46.5

GRAHAM SUTHERLAND (1903)

52 *Welsh Landscape with Roads* 1936
Oil on canvas, 61×91.5

53 *Entrance to a Lane* 1939
Oil on canvas laid on hardboard, 61×51

54 *Green Tree Form* 1940
Oil on canvas, 79×108

55 *Devastation, 1941: An East End Street*
1941
Ink and gouache on paper mounted on
cardboard, 64.5×113.5

56 *Horned Forms* 1944
Oil on board, 81×64

57 *Crucifixion* 1946
Oil on hardboard, 91×101.5

58 *Somerset Maugham* 1949
Oil on canvas, 137×63.5

59 *Head III* 1953
Oil on canvas, 114.5×88.5

60 *Hydrant II* 1954
Oil on canvas, 112×90.5

61 *Form over the River* 1971–2
Oil on canvas, 221×309

VICTOR PASMORE
AND CONSTRUCTIVISM

Victor Pasmore (1908)

62 *Nude* 1941
Oil on canvas, 61×51

63 *The Quiet River: The Thames at Chiswick*
1943–4
Oil on canvas, 76×101.5

64 *Square Motif, Blue and Gold: the Eclipse*
1950
Oil on canvas, 46×61

65 *Abstract in White, Black, Indian and Lilac*
1957
Painted relief construction, 106.5×117×4

66 *Linear Motif in Black and White* 1960–1
Oil and gravure on formica relief, 122×122

67 *Black Abstract* 1963
Oil on board, 152.5×153×5

68 *Synthetic Construction (White and Black)*
1965–6 Relief of formica, painted wood and
perspex 122.5×122.5×27.5

Kenneth Martin (1905)
69 *Rotary Rings* 1968
Mobile in brass, 93.5×58.5×58.5

Mary Martin (1907–1972)
70 *Spiral Movement* 1951
Painted chipboard, 46×46×9.5

Anthony Hill (1930)
71 *Relief Construction* 1960–2
Rigid vinyl laminate and aluminium
sections bolted to a hardboard base and
wooden frame. 110.5×91.5×4.75

FRANCIS BACON (1909)

72 *Three Studies for Figures at the
Base of a Crucifixion* c. 1944
Oil on hardboard, each 94×74

73 *Figure in a Landscape* 1945
Oil on canvas, 145×128

74 *Study of a Dog* 1952
Oil on canvas, 198×137

75 *Study for a Portrait of Van Gogh IV* 1957
Oil on canvas, 152.5×117

76 *Reclining Woman* 1961
Oil and collage on canvas, 199×141.5

77 *Seated Figure* 1961
Oil on canvas, 165×142

78 *Study for a Portrait on a Folding Bed*
1963
Oil on canvas, 198×147.5

79 *Portrait of Isabel Rawsthorne* 1966
Oil on canvas, 81.5×68.5

THE FORTIES AND FIFTIES

Roger Hilton (1911)
80 *Painting February* 1954
Oil on canvas, 279.5×152.5

Reg Butler (1913)
81 *Woman* 1949
Forged iron, 221×71×48

William Scott (1913)
82 *Ochre Painting* 1958
Oil on canvas, 86.5×112

Kenneth Armitage (1916)
83 *People in a Wind* 1950
Bronze, 65×40×34

Peter Lanyon (1918–1964)
84 *Thermal* 1960
Oil on canvas, 183×152.5

Patrick Heron (1920)
85 *Horizontal Stripe Painting* 1958
Oil on canvas, 279.5×152.5

Lucian Freud (1922)
86 *Girl with a White Dog* 1950–1
Oil on canvas, 76×101.5

87 *Francis Bacon* 1952
Oil on copper, 18×13

William Turnbull (1922)
88 *Spring Totem* 1962–3
Bronze and rosewood, 90×148×43

Eduardo Paolozzi (1924)
89 *Forms on a Bow* 1949
Cast brass, 48.5×63.5×21.5

**A NEW APPROACH TO THE
FIGURATIVE IMAGE**

Eduardo Paolozzi (1924)

Ten Collages from 'Bunk'

90 *I was a Rich Man's Plaything* 1947
Collage, 35.5×23.5

91 *Lessons of Last Time* 1947
Collage, 36×24.5

92 *Meet the People* 1948
Collage, 36×24

93 *It's a Psychological Fact Pleasure Helps Your
Disposition* 1948
Collage, 36×24.5

94 *Sack-O-Sauce* 1948
Collage, 35.5×26.5

95 *Real Gold* 1950
Collage, 35.5×23.5

96 *Windtunnel Test* 1950
Collage, 25×36.5

97 *Yours Till the Boys Come Home* 1951
Collage, 36×25

98 *Was This Metal Monster Master—or Slave?*
1952
Collage, 36×25

99 *The Ultimate Planet* 1952
Collage, 25×30

Peter Blake (1932)
100 *The Fine Art Bit* 1959
Enamel paint, wood relief and collage on
board, 91.5×61×2.5

Howard Hodgkin (1932)
101 *Dinner at West Hill* 1964–6
Oil on canvas, 42×50

R. B. Kitaj (1932)
102 *Isaac Babel riding with Budyonny* 1962
Oil on canvas, 183×152.5

Patrick Caulfield (1936)
103 *Battlements* 1967
Acrylic on canvas, 152.5×274.5

Derek Boshier (1937)
104 *Identi-kit Man* 1962
Oil on canvas, 183×183

David Hockney (1937)

105 *The First Marriage* 1962
Oil on canvas, 183×214.5

106 *Mr and Mrs Clark and Percy* 1970–1
Acrylic on canvas, 213.5×366

Allen Jones (1937)
107 *Man Woman* 1963
Oil on canvas, 214.5×189

ABSTRACT PAINTING AND SCULPTURE IN THE SIXTIES

Anthony Caro (1924)

108 *Yellow Swing* 1965
Painted steel, 179×198×397.5

109 *Piece LXXXII* 1969
Forged steel with found steel elements,
painted, 44.5×120.5×146

Eduardo Paolozzi (1924)
110 *Rizla* 1965
Aluminium alloy, 165×211×150

Robyn Denny (1930)
111 *Garden* 1966–7
Oil on canvas, 244×198

Bridget Riley (1931)
112 *Late Morning* 1967–8
Acrylic on canvas, 228.5×359.5

Richard Smith (1931)
113 *Riverfall* 1969
Acrylic on canvas, 228.5×686×35.5

Bernard Cohen (1933)
114 *A Matter of Identity I* 1963
Oil on canvas, 244×244

John Hoyland (1934)
115 *17.3.69* 1969
Acrylic on canvas, 198×366

Phillip King (1934)
116 *Tra-la-la* 1963
Painted fibreglass, 274.5×76×76

NEW DEVELOPMENTS

Victor Burgin (1941)
117 *Room* 1970
Paper, 18 sheets, each 28×20

Michael Craig-Martin (1941)

118 *4 Complete Clipboard Sets:*
 1. Clipboard
 2. Sheet of paper
 3. Pencil
 4. Written Title
 5. Eraser
 Extended to 5 Incomplete Sets with
 Photograph Replacements 1971
 Assemblage of letrafilm, plastic tape, paper,
 paper-clip, written text and card, in 5 units
 each 77×51

Barry Flanagan (1941)

119 *Pile* 1968
 Hessian, 32×52×48

120 *No. 5 '71* 1971
 Wood, 63.5×264×251.5

Gilbert and George (1943, 1942)

121 *Balls or The Evening Before the Morning*
 After—Drinking Sculpture 1972
 114 photographs, 210.5×438.5

Stephen Buckley (1944)

122 *Nice* 1972
 Oil enamel and cryla on duck, 81×91.5

Hamish Fulton 1945

123 *A Condor* 1973
 3 photographs, mounted and framed
 59×84.5

John Hilliard (1945)

124 *Across the Park* 1972
 4 photographs, mounted and framed
 each 108×55

Richard Long (1945)

125 *A Hundred Mile Walk* 1971–2
 Map, photograph, text, 22×50

Keith Milow (1945)

126 *1 2 3 4 5 [6] B* 1970
 Resin, crayon and fibreglass
 122×213.5×10

John Davies (1946)

127 *Dogman* 1972
 Fibreglass, 28×18×26.5

128 *Head of William Jeffrey* 1972
 Fibreglass, 30.5×10.5×39.5